Blood Kiss

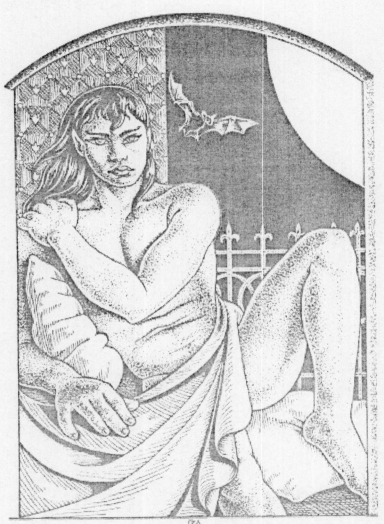

Blood Kiss

Vampire
Erotica

Edited
by
Cecilia
Tan

Circlet Press

Boston, MA
1994

Blood Kiss: Vampire Erotica

edited by Cecilia Tan

ISBN 1-885865-00-7

Circlet Press, Inc.
PO Box 15143
Boston, MA 02215

Printed in the United States of America

"Loved to Death" previously appeared in Club International, February 1990 issue.
"The Hunger" previously appeared in Fresh Blood, August 1994 issue.
"Wanting" previously appeared in Blue Blood, issue #4/ V2.1
"The Brass Ring" is excerpted from the forthcoming novel Diary of a Vampire, Masquerade Books, New York, 1995.

For more information about Circlet Press erotic science fiction and fantasy titles, please send a self-addresses stamped envelope to the address above. Retail, wholesale and bulk discounts available

Table of Contents

Editor's Note

I believe that the vampire is a perfect subject for erotic fantasy. First, the vampire has always been viewed as a sensual creature. In past eras of human history this was seen as evil, like all "sins of the flesh." But I would like to think that in America in the 1990s some of us have a finer appreciation of the wonders of sensuality, the primal attractions of flesh and blood, the magic of erotic surrender. We think of vampires as hunters and as seducers of their prey, the hunt as primal and animal as sex itself. Second, the vampire has always been outside of the strictures of "common" propriety, the chastity of marriage broken, the purity of the virgin defiled, and vampires hunt both men and women, so it is no surprise to find gay and lesbian, bisexual, transgendered and kinky vamps herein.

Third, sex and death are as deeply intertwined as sex and life are, the "little death" we call orgasm, and the intense power of life that is erotic power... and congress with a vampire could mean death, everlasting life, or both at once. The vampire embodies both extremes.

You may find that the vampires you will meet in these pages, are not quite the same as the bloodsuckers commonly found in many horror novels. These stories concern themselves with something more than gore and serial killers. These stories celebrate the eroticism inherent in the vampire mythos, and elucidate it, drag it out into the open rather than sublimating it. Fear becomes excitement, predation becomes seduction, and death becomes eros. I invite you to explore and enjoy the sensual side of the night.

Cecilia Tan
October 1994

The Perfect Form

Pat Salah

10:15 on a Saturday night. Pandemonium is already packed. Arriving ten minutes from now and I'd be cueing in the rain for half the night. I pay my cover and spot Reg and Suzy shooting some stick. Kiss. Kiss. Hi. Hi. Throw my leather down and cruise up to the bar, scoping the action. Used to be the Olympia Theatre before Eckhart bought it up. Mighty pretty place: Victorian parlor decor all in red and black and gold; rococo frescoes on the walls and huge fuck'n stained glass skylights, and girls dancing in the opera boxes, except the top two where Eckhart holds court and toasts his most honored guests. I love it. Too bad Eckhart owns it. Guy's a pig.

Notice Dré working the floor, looking sweet as usual in green velvet and fuck'n thigh-high docs, black braids slap'n against her tits. Don't know how the prick does it but he's got the rockingest chicks in the city working for him: all his barmaids take a turn in the boxes, and, when they're on the floor,

1

it shows. Like when I spot Colette my eyes are
nailed to the place where the back of her shift rides
down around the curve of her ass. So I nearly knock
some pubescent punker chick over. Don't see many
of those around here these days.

Essen pours me a Kier, eyebrows arched, painted
mouth making a moue that's supposed to be ques-
tioning, provocative. Guy's such a poseur. Used to
think he was so styl'n, when he played with Univer-
sal Rejection. His punk days. My punk days. Now
the Elders of the Kin—goddamned Vampires is
what they are—openly walk the earth and anybody
who knows shit hangs at Pandemonium and em-
braces the Gothik lifestyle. I read it in *Interview*
magazine: Montreal, the Canadian New Orleans.
But fuck, *Propaganda* said the exact same thing. I
swear. Life has gotten weirder, its not just me.

Trade-offs. Like when I was a punk I hung with
a regular crew of pretty cool guys. When the Vam-
pires came out of hiding I turned Goth. Most of
those guys became warm fascists—shaved their
heads and started jacking off to the idea of staking
members of the Kin. Fat fucking chance. Nothing
can kill the already Dead. I moved into a cooler
crowd. Cooler, as in, Dead-loving, and also, as in
chillier. Lars didn't need to pull attitude to be cool
though. A good guy. When the Vampires came to
town we both knew what we wanted. He got it, sort

of. They moved on to some new scene, taking him with them. But they'll be back—Lucrezia, Lars' maker, said so in the last *Engarde Quarterly*. These days I'm casual with lots a folks. Keep to myself. Which suits. It's how Lars got taken.

Man! Didn't even recognize him the only time I saw him after the Kin Elder sunk her teeth into his neck. At least that's the rumor, that she's an Elder, which makes sense, she is their spokesperson. Besides the young ones aren't supposed to be able to make new ones: otherwise he would have taken me, I'm sure of it. We both swore we would. The other thing they say is that the young ones are slaves of the Elders that make them. But that's gotta be bullshit, a system like that would never work, because they're all immortal: that would mean they're all slaves of one or two really ancient Kin which is obviously ridiculous. Of course with immortals, you've got to wonder what would count as elder anyway. Over one hundred years, for sure. One thousand? And how could you tell?; Thom says they're shapeshifters besides. Lars Changed. Fuck, he was beautiful...

Remember how he appeared before you out of the darkness of the club, his black hair in curls, with waif eyes and rose petal lips, an ingenue, and yet so pale and tawdry in a red satin dress and too much

blush—like a prostitute dead and risen under a lurid sun. Or, as the Vampire thought, like a boy too pretty to be left alone with his sex, too in love with his cock to be made a girl: only after the Change was worked upon him, to become as pale as the bones of the moon. The Vampire left him neither living nor dead no longer wholly male nor quite female. That one shaped his body to suit his deepest desires, during the bloodletting when its will was strongest. It walked his dreams and saw his wishes and answered them. It imagined Lars as voluptuous as any Vargas girl, a body fitted to his gutter angel face and his slut's soul. The dreams of the Vampire possess such force. What a shock for dear Lars when he woke. His is the perfect form aspired to by those tormented men who hound surgeons and psychiatrists, pointing to their men's magazines, begging: "Make me like her. Make me Marilyn, Bardot, Madonna. Inside I'm more woman than any woman." Though Lars is not complete in that respect. He still has his beloved cock, and of course, he is Dead. All this, and more, you knew in that first moment of matched gaze. You knew the stories of the Vampire's preternatural strength, both of will and of form, to be true. You knew it could have you as it pleased—you would give your blood or flesh up willingly. Lars would not have to take you forcibly, though it thrilled you to think the thing he had become could. That was, after all, your pact.

And moments after Lars left, you were drowning in the absence of its perfume, drowning in your memory of its beauty. Until then you had caught mere glimpses of the Kin, in the dark, in your dreams: you had never seen one revealed. Now you know. The supple white length of neck, delicate curve of ankle beneath silk, arch of red rhinestone stiletto... Then you noticed you had come, your legs were weak, and you mouthed: "Come back to me," pleading.

Slight pressure against the lace cuff of my blouse has me nearly jump out my skin. It was like I was tripping out; I guess the Yin is starting to hit; Thom said it comes on stronger every trip, but fuck, I went from thinking about something to reliving it, except that last bit, I want to be a Vampire, sure, who doesn't, but not like that, like Lars. Fuck! "Your memory, a guided tour with commentary by Vincent Price." Jeezus! Actually, that voice was more honeyed than slimy, like Christopher Walken, or...

"Mr. Eckhart!"

"Hello Brett. You looked faint for a moment. Are you not feeling well?"

"I, ah, no. I was just feeling dizzy there for a minute. Uh, were you talking to me, I could swear I..."

The owner of Pandemonium just smiled at me. "You seek the Vampire, as we all do. They infect us

with a love of too lush flowers, overripe fruit, the pungency of decay. To smear ourselves in the earth of gravesites, to open our wrists and quaff one anothers' blood to clotting: this is our self-immolating desire, this is what they have done to us with their luscious death. We are all sodomites now, and vain primping things, compulsive in our personation of those other dead, goddesses of the screen. The world has seen terrible changes these last few years. And we yearn for more.

"Still They come but rarely. Their ways are mysterious to most of us—"

"Not to you Mr. Eckhart. They obey—" It was Essen, draped over the bar, one hand twirling a strand of auburn locks, while the other toyed with his Kier. Momentarily, I wondered if anyone drank beer anymore.

Eckhart turned and softly hissed, "Enough, bitch. Don't you have work to do?", so quickly, I nearly missed it. Essen was fleeing down the length of the bar, his heels clicking, as Eckhart returned his attention to me.

"You've grown so pretty these last few months, almost as pretty as Lars was, before he was taken. It is almost as if your body is yearning for the Change it sensed in him, striving beyond its natural inclination for that fatal delicacy.

"Have you been sampling Thom's chemicals?"

I pause before answering, partly to cool my heels: "Pretty," my ass. The guy's a slimy s.o.b. but obviously I can't say jackshit to him if I don't want to be banned. Which I don't. Pandemonium is the only place north of New York the Vampires frequent. Anyway, Thom couldn't work the club without him knowing, so I just mumble, stupidlike, "Yin. Gets you pretty fucked up."

"Ah. It is a popular intoxicant. But surely you know that in sufficient doses it has other effects."

"They say it attracts the Kin, if that's what you mean."

"Attracts the Kin. As like to like. It brings out a certain luster in the skin, softening and slowing the growth of body hair. Some say it slows the aging process. It makes one more sensitive, sensuous, and too, almost empathic. Certainly it incites desire. But Yin can only take you so far. You should come to one of my gatherings in the upper chambers."

This is getting to be too much. "I'll think about it. Thanks man."

Eckhart continues to smile in that superior way of his. "Only with our help, will you stand a chance of winning their favor, when they return."

"What do you know about that?"

"As your friend Essen noted, I have some knowledge of their ways."

"Essen ain't my friend and... and I'll think about it. Excuse me, I think I see someone I need to talk to."

I can almost sense the cold set of his face as I turn and cut through the crowd towards the dance pit. Sound system's booming retro Sonic Youth: *Cool thing play'n with the kitty, now ya know ya sure look'n pretty.* I know it's a risk pissing Eckhart off like that but I need to get away from him, think about what he said. I know what goes on at those gatherings of his. One hundred days of Sodom style orgies is what I heard. Sometimes you can see them in the opera boxes, fucking and sucking, whipping one another. I should jump at the chance, because he's right, they're why the Kin come here. Everybody knows that. Suddenly, I'm not sure. In my head I see Lars the Vampire again, his lush tits spilling out of that gown, his eyes all green fire and alien. What if joining the Kin makes me like that. Maybe I should just get pissed and skank some warm chick. God knows there are lots of tasty ones on the floor.

It is foolish of you to deny him.

I look up at the chick stepping out of the pit towards me, go suddenly dizzy. She's totally delish and its only after a second I recognize her. Upswept mass of jet ringlets, smoky eyes with long shadowy lashes; lips puffy and bloody red; still it seems a

child's face, scared by those lips, by the rings through her eyebrows, ears, nose. She's teetering on spike heels, as if drunk, and her breasts shake in her jewel encrusted black bustier. One of the dancers. Felicia, I think's her name. Then it comes to me. She's Dead. Kin. The only Kin I've met. I don't know I could have missed it before. *Lars.*

Dance with me pretty boy?

It's not a request: without noticing myself do it, I step towards her, begin moving with the low beat of *Bela Lugosi's Dead.* It occurs to me that she hasn't opened her mouth to speak to me.

What's happened to you?

She's looking at me askew, plucking with crimson nails at the netting of her black petticoats, distractedly. She's trembling slightly—it's only been a few months, she's still newly Dead. My god, how could Lars look so choice. Behind her the crowd has turned to watch us. They've recognized her for what she is, the way I have. The closest appear paralyzed: hands snaking towards Her, frozen midway.

Don't you realize Eckhart represents your best, maybe your only, chance of joining the Dead?

Stealing myself, I ask: "What about you? We had a deal. A pact."

God, Brett—I could just have you for a snack. I'm so hungry. Besides I'm weak, Brett, forty-ninth

*generation, Lucrezia says. My blood's thin. What
kind of Vampire would I make?*

She's looking at me straight on now, sizing me
up, for dinner maybe. She must be delirious. What
she's saying makes no sense. I've got so many ques-
tions. Lars. Suddenly, I'm hard, hot for her. Not
Lars. Felicia. I reach out and stroke her cheek.

Brett, don't. Go to Eckhart. Flatter him. He likes
you. He'll get you a strong maker. Thirtieth, maybe
even twentieth generation. You don't have to be like
this.

Ignoring her, "Don't fuck'n mock me, Lars. You
know Eckhart doesn't know shit. You're here. I
want you to do me. Come on." I'm feeling foolishly
bold, grab her hips and pull her to me. Surprisingly
she comes. I smell roses.

*Brett! Don't! I haven't been fed in a long time.
Don't you recognize me?*

Her body is so light, like a bird's. I lift her to me.
Kiss her. It's easy, she's not Lars any more, she's my
Vampire lover. "Of course I do, Lars. If you won't
keep your promise, then feed on me. Better that
than to end up one of Eckhart's pets."

Still suspended in my arms she grins, loopily.
One of Eckhart's pets. *Okay Brett, if that's what
you want. I bet you'll make a pretty one.*

Then she's on me and I don't know how I ever
could've doubted her strength: her talons, her teeth

are inside me. The first claw, tears through denim and inner thigh, paralyzes. Canines rip in and out of throat, breast, belly, as other nails rake down expanse of back. Blood's leaving my body through a dozen excruciating wounds: simultaneously rushing to erect penis. A fierce heat, the trajectory of her teeth, closed around groin. The world explodes.

Darkness tracing a cool breeze across naked body. Icy all over. Feel—muscle, skin stretched. Where? Trying to move, feel satin rustle beneath me, but don't have the strength to raise the head from the pillow it rests on. I am in a bed, somewhere. Eyes adjust to the dark and I can see tree shadows dancing through the room, the tops of French doors thrown open, a corner of night sky holding a sickle moon. From outside comes clearly the sound of loons, crickets, wind and ocean. I think: I'm in another country. Blood's chill moving in my veins. Then abruptly, what must have wakened me: an exquisitely fine tracing of pain across my chest. Nails, like razor blades, moving delicately, slowly, almost slyly in what I imagine as the most elaborate of patterns rising upon skin, like tattoo, like scars. Something sharp and hard pressing against, in and out my ass. I hear a slow moan, long and low, and then after a time her response, moist exhalation of breath all over my body; her tongue

scraping like a cat's along my inner thigh and a
wash of hair breaking over my belly, then the puff
of lips tender and yet taut around my cock, her
tongue scraping along it, flaying with little barbs.
This goes on and on, my body engorged with blood
and sweat, and swimming in it—I'm suspended,
almost dreaming. I see Eckhart hovering around the
bed, watching, smiling. The pressure is unbearable.
Until she begins the draining. For a moment, I'm
burning water. Then, gone.

When I wake again, it's morning. I know with-
out opening my eyes. I feel the shimmer of the
world around me. Everything is crystal. That clear.
I'm no longer warm. I see through my closed eye-
lids. I'm alone, for the moment. The room has the
look of one of Eckhart's bordello affairs done in
rose satin and velvet, excessively feminine: the
canopied bed I'm in, a huge skirted white ward-
robe, a pink and white vanity table, the diaphanous
pink drapes on French doors leading to a balcony,
a white shag rug.

Memory washing back, lays over my vision. Sex
with Felicia. Lars. On top of me, sculpting me with
tongue, claws, dreams, blood. I can feel her some-
how, inside me, in blood, semen.

I'm lying in bed. But I can see myself. As if
watching from above. *My how you've changed—*

Eckhart's voice echoes in my head. What was Lars trying to tell me, before...

I'm a little girl—a naked porcelain doll with dabs of rose at the lips, nipples. Golden blonde ringlets, frame delicate features. Eyes turquoise blue. Lovely small breasts. Silky smooth little cunt. I look maybe thirteen. But what a perfect thirteen. More like a pixie or a sylph than a vampire, even the incisors behind the pursed bow of my lips are tiny, delicate.

Eyes open, I sit up and shrug away too blonde hair. Little fingers cup my breasts—my skin is so pale and baby soft! I don't know why I'm so calm. It's like I'm waiting for something. I get up and walk over to the huge vanity mirror on the doors of the wardrobe. I can see myself in it, my new self. It's not just my body, she's done something to my mind, because I can see from my reflection that my every move is totally sensuous, sexy, provocative. I'm standing on tippy toes as if I were in heels, my breathing makes my breasts jiggle, and I can't help but flutter my lashes, purse my lips as if I were gonna blow some guy— This is crazy. I wanted to be made a Vampire, not some fucking sex kitten! Why would she do this to me? Just looking at my reflection makes feel funny, wet in my pussy.... My hands caress, trembling, the curve of my now pillowlike ass, insert a finger between virginal lips.

I can't believe I'm thinking like this, doing this. The feel of my fingers brushing between those two soft lips, catches my breath and my nipples tighten up. I settle back down onto my ass, my back, immersed in the sea of white carpet. I wince in slight pain as one too sharp nail flicks against my pussy lips, another swirling round my clit, it's hard, swelling, but not like my dick used to. One hand massaging my hardened tits and my cunt, so soft; wet with blood pulsing through it. I wonder if I'm still dreaming—getting hotter, my fingers stroking a steadier rhythm inside me, my pussy stretching to fit more in, moving faster. I can't believe what they've done to me. I want to fuck them both, Eckhart and Lars, I mean kill them. I....

I don't hear them until they are practically right on top of me. Eckhart. Lars. I'm buried in the shag, taut skin burning all over, on my back and ass, my pussy thrusting up, humping my hand, my tits and pussy bleeding—the knowing smiles on their faces don't matter, I'm coming blood, sweating blood, crying it under their feral gaze.

Until at the last, he must know I'm on the verge, Eckhart nods to Lars, and her hand dives down into my hair and whips me to my feet.

"No fair," I huff, surprised hearing for the first time, the breathless purr of my voice. My pussy and

tits are throbbing, and it's humiliating but Lars and Eckhart are just turning me on more.

Eckhart is wearing his usual tux and tails, and is looking smug. Lars—she, I can't help but thinking of her as she, despite the huge erection she is sporting—is naked except for her heels and stockings. *Are you happy now Brett? I've made you a Vampire, just like we promised.*

Eckhart grins, speaks in my head. *So sorry to interrupt, but we thought it time to proceed with your education. Under the circumstances you have turned out quite nicely, Brett, I must say. A good thing considering you probably lack the strength to Change. You are something of a weakling among the Kin. I do look forward to using you later. For the moment though I merely intend to claim you from the stupid slut who was so eager to make her own child.*

I don't feel myself moving, it's as if his will has taken over my limbs. Suddenly I'm in his arms, rubbing my pussy against the hump of his cock. I hear myself moan "Please. Fuck me! Please."

His hands slip about my waist, lift me, and gently he begins kissing my breasts, his tongue lapping the blood off them. The heat in me gathers. I scream as teeth pierce the flesh around the nipple, my vision narrows to a thin band of red.

As other colors return me to the room, I realize I'm sitting at the vanity. Lars is fussing with my hair. She looks sad. I hear her voice in my mind. *You must call me Felicia now. That is the name my maker gave me. Perhaps you can keep your name though. After a moment she adds, I tried to tell you. Eckhart liked you. Perhaps he still does, but now it's too late.*

I must look puzzled because she continues. *Look at me. I'm a Vampire. You've felt how powerful I am. But among them I'm nothing, nearly human. I belong to the youngest generation of Vampires ever. Until now. My maker, Lucrezia is almost two hundred years old, Brett. She can Change her form, send her mind on the wind. Things I might never be able to do. She's so much beyond me that I can't imagine it—but she's still got to bow and scrape to most of our race. We're slaves Brett. Creatures who exist to serve the whims of our elders.*

"Can't we run away. Escape." My little girl voice doesn't even convince me. Lars just laughs gently.

Don't get excited, it won't do any good and I've just finished your make up. You don't want to muss it before you go down to work. You don't get it at all, do you, Brett? You know who Eckhart is? Of course not. It's not his oldest name. Lucrezia once told me what his first name was: Arpad, that's old Arabic or Aramaic, or something. It meant great

*warrior, literally, "he who tastes first blood". He's
the one, Brett, the Necromancer, the self-created
Vampire who started all this. There is no running
away from him. He owns us, all of us.*

"Oh", I hear myself murmur, feeling suddenly
very strange, both sleepy and giddy. Lars— Felicia,
is finished with the comb and is standing back to
survey her work.

*Very pretty. The clients will be pleased to see a
new girl. Now don't get all glum. You're immortal,
beautiful, powerful and you live for pleasure. Its not
all that bad. Now get up and take a look at yourself.
The old Brett would cream his jeans watching you
dance in one of the opera boxes. So would the old
Lars.*

Swaying to the mirror—wondering how I man-
age the lift of the heels, at least four inches—I know
she's right. Part of me is already starting to like this.
As I stare at the fresh faced darling posing in the
mirror, bust out, hips cocked, I see the beginning of
a smile pulling at her rose colored lips. Felicia has
done me all nouveau hippie: kohl makes my eyes
deep, dark and sexy and my platinum mane is piled
atop my head, with long curly tendrils down each
side. The dress is a pink chiffon babydoll that posi-
tively depends from the tips of my breasts, short
enough to glimpse the tops of my white net stock-
ings. The heels are pink patent leather with ankle

straps. I squeeze my thighs together and blow my-self a kiss. A girl couldn't be more feminine if naked. My tongue plays over concealed incisors that have just started to throb. I send for the first time: *Oh, Felicia, I'm a good girl, aren't I?*

Cinnamon Roses

Renee M. Charles

I don't know if it's be-
cause people buy so heavily into the mythos of
vampirism (y'know, the gal/guy-in-a-sweeping-
cape-swooping-down-on-her/his-prey's lily-white,
blue-veined throat batcrap), or if it's because they
have this idea that we vampires just need a suck of
blood every day or so to keep body and soul in one
just slightly undead package, but being a twentieth-
century working vampire is *not* just a matter of
staking out a little patch of earth under an aban-
doned warehouse somewhere out in the hinterlands
of the city—c'mon, get real.

Spending twelve or more hours a night biting and
swooping and not much else is fucking *boring*. And it
doesn't contribute squat towards the rent or utilities on
my basement apartment in Greenwich Village, either.

Besides, just because a gal gets a little more than
she bargained for during an admittedly dumb
unsafest sex of all fling with some guy she met in
some club she can't even remember the name of
(oh, I made him wear a condom, but that didn't

protect my neck...) it doesn't mean that she suddenly becomes the reincarnation of Dracula's Brides. I still needed to make a living, and since I'd been a barber/hairstylist before...well, you've got to admit, scissors and razors do have a way of occasionally drawing blood.

And from personal experience, I know that vampire bites feel a heck of a lot like the touch of a styptic pencil...down to the not-quite-needle-sharp tip pressing down on warm flesh.

Getting my boss to let me change my hours from mid-afternoon to evening to evening to pre-dawn wasn't difficult; the place where I work, the Heads-or-Tails, is one of those places that specializes in punk/SM/adventuresome types—full body waxes, razor and lather shaves, even a little extra stuff on the side (regular customers only—cop shops can't afford to send in decoys week after week) so it isn't unusual to see just about every type of person coming in for that special cut or shave at any hour of the night.

And at $100 bucks a pop and up per session, the Heads-or-Tails never closes. So when one of the stylists demands a *right now* change in working hours, the management is more than happy to oblige, especially when she (as in me) keeps drawing repeat nocturnal customers....

Another misconception about us vampires is that if
we keep on doing what we do best—a.k.a. neck-
biting and blood-sucking—eventually we'll infect
the entire fucking world, because our victims will
infect victims of their own, and so on until you're
looking at one of those Andy Warhol's *Dracula* situ-
ations (the whiny vampire strapping his coffin on
top of the touring car and motoring off in search of
fresh "wurgin" blood). Get off it, do you think that
one sip from a person is enough to make them go
mirror invisible (which is another load of
bullsheet—sorry, but the laws of physics don't work
that way, though it makes for a nice special effect
in the movies, I'll admit!) and start draining the
family dog for a pre-bedtime snack? I had to spend
a week with my nightclub Nosferatu before sunlight
began to make my skin itch, but I can still put on my
lipstick in the mirror, thank you!

So, a slip of the disposable razor here, or a nick
with the scissors there, and it's good-bye hunger,
but not necessarily hello fellow nightwalker. Not
unless *I'm* interested in some continuing compan-
ionship over the course of a month or so. And even
then, I make sure I know the potential victim well
enough to be sure that she or he will be in a posi-
tion to tap into a private food supply without
attracting attention. C'mon, do you think that some
of those E.R. nurses on the graveyard shift keep

missing your veins by accident? Or those dental technicians who can't seem to clean your teeth without drawing blood?

But sometimes, no matter how much a gal exercises caution, and forethought, not to mention common-sense, there will come the day when that certain customer walks in—and every vein in my body, every blood-seeks-blood-filled throbbing vein, cries out to my brain, my lips, my cunt: *Take this one ... don't ask any questions, don't think about the night after ... just take this one.*

(Doesn't even matter if this one is a gal or a guy; skin touching skin is gratification enough, and fingers and tongues more than equal a prick ... there's nerve endings enough to go around all over the body).

For me, the first signal of a customer being a *taker* is their smell. The smell of clean, healthy blood surging under their veins just a few millimeters under the unbroken flesh—for each of us, the name, the associative taste, we give to that good blood-odor differs. For me, it's cinnamon; cinnamon that's been freshly scraped from the stick, that raw, so sharp-it tweaks-your nostrils tang, so fresh and unseasoned the smell soon becomes a palatable taste even before the first drop caress my tongue.

(How else do you think vampires avoid HIV and AIDS? Once you've had a whiff of that moldy-

grapes and stale-bread odor—naturally, this per-
ception differs from vampire to vampire—you can
smell a victim coming at you from two blocks away.
Three if the wind is blowing past them.)

Oh, all non-infected normals smell somewhat
like cinnamon to me now; as long as you're reason-
ably healthy, the cinnamon-tang is there, but in
some people ... well, it's more like a cautious
sprinkle of the spice over toast, or across the top of
an unsealed apple pie. Maybe it's all the stuff
people take; additives, drugs, you name it. But in a
taker, that fragrance is a living part of them, like an
extra finger or breast. Richer and more lingering
than the smell of sex, more piquant than ejacula-
tion seeping out of your crevices.

But the blood isn't the whole reason for that
desire to own, to make a normal into a new-blood
kin; even though it is the most tangible reason; for
me (at least), there has to be a certain look in their
eyes, a vulnerability that goes deeper than mere
submission. The look which says *What I am now is
not all I could be.* Doesn't matter if the look comes
from eyes in a straight or gay or female or male
body, either. Like I said before, there's nerve ends
a plenty all over the body. Age isn't a biggie either,
although most of the clientele of the H. or T. is
youngish, adventuresome.

Color, background, whatever—none of those things matter either. Maybe because we vampires live so much in ourselves, and are ruled by what runs through our bodies and not over our bodies, that which is within others speaks to us so eloquently, so desperately.

Even if they themselves do not realize that inner need....

Despite the air conditioning in my private cubicle (set on 72° instead of something cooler—newly shorn flesh, especially large areas of it, does tend to chill easily) the muggy heat of the late July night managed to seep into my workspace that particular evening, and I was just about to slip off my panties and position myself directly in front of the unit for a few moments when that smell hit my nostrils. *Taker coming.* I quickly lowered my suede skirt and smoothed down the short-cropped hair which covered my head like a sleek skullcap, before glancing about my workspace to make sure everything was in perfect, customer-ready order. Unopened bags of flexible-blade razors—check. Cleaned and oiled clippers, trimmers, edgers—check. Shave creams, mug soaps, depilatories—check. Thin rubber gloves—not that I really needed them, but Health Department regulations are regulations—check. Hot wax—check.

By this time, I could hear footsteps coming
closer down the narrow tile hallway between work-
stations. This one's a woman, my brain told my
body. My labia began to do a jerking, twitching
dance against the already damp fabric of my pant-
ies, but I made my other set of lips form themselves
into that slightly vacant, blandly professional smile
all of my customers got when they parted the thick
curtains separating my cubicle from all the others
in the H. or T. salon.

In deference to the heat without, she was wear-
ing a halter top, shorts, and slip-on cotton-topped
shoes, the kind the Chinese make by the thousands
in an hour or so. Can't rightly say I remember what
color any of her clothes were; but *her* colors ... well,
you know how it is when you see your first really
brilliant sunrise, don't you? (Even though those are
forbidden to my kind, the memories—the skills,
and the like to need to go on surviving—remain.)

Within, she was a molten cinnamon, and with-
out, she was a sunrise, or a sunset ... whichever is
the most vivid, the most heart-aching. Russet hair
flecked with streaks of natural gold and near-or-
ange fell across her forehead and shoulders like lava
arrested by a sudden chill, while her eyebrows were
twin arcing bird wings above green like gumdrops
and suck-it-'till-your-mouth-puckers hard candies,
or new leaves in the sunlight I could no longer see

green, green eyes. And she had the type of skin that let that cinnamon-scraped-from-the-stick lifeblood of hers shine through in delicate vine-looping trails of palest filtered blue and labia pink. Real redhead skin. And I don't know why it is, but so many true redheads like her are so naturally thin, not to the point of bones sticking out, but covered with just enough flesh. Breasts small enough to cup in a woman's palm, but the nipples would be big and hard enough to make an imprint on that same smallish palm.

It was painful not to be able to drink her in for as long as I wished; but staring at the customers, especially new ones (and most especially takers) can sometimes send them turning on their heels and diving through those heavy curtains, never to be seen or smelled again. Fortunately for me, she was nervous enough not to notice that I was staring at, no, *devouring* her, for her green-beyond-green eyes were timidly lowered, darting to a picture she held in her left hand, then back at a point right around my waistline. She probably didn't even realize I was doing the looking.

Which suited me just fine.

I could see the picture she was holding; a newspaper clipping of that one model, the French-Canadian one with the dragon tattooed on her shorn scalp. Well, at least it wasn't Susan Powter; I'd have been

loathe to try and bleach that exquisite liquid cinnamon hair of hers.

"Uhm, the woman up front said you do...what'd she call it? 'Full head shaves?'"

Customer or not, taker or not, I felt a sharp pang not at all unlike the first time my lounge-lizard Lothario sank his incisors into my neck when she said that. Even if it meant being so close to her exposed neck, shearing off that mane wouldn't give me the usual pleasure I felt as my labia quivered in time with the buzzing hum of the heavy-duty clippers which would send my hand and arm to quivering as I'd take off the longest layer of hair. Usually, shearing off hair could be a sensual, aesthetic experience above and beyond the sight of those subcutaneous veins resting in the flesh of the newly exposed neck; the way it rippled as it fell away from the scalp, drifting down in feathery piles to the floor, sometimes thick swaths of it touching my bare legs on the way down, tickling like a man's hairy leg brushing against my own, or the way light picked up the sheen of untanned, milky skin under the quarter-inch stubble, and as the lather was swept away by each pull of the blade, the play of diffuse light on naked flesh and the silky feel of it through the thin rubber gloves were usually enough to give me an orgasm on the spot.

Then again, most of my customers had average, unremarkable hair. Being obvious about my potential pleasure would've driven her away before I'd come even within tasting distance of her exposed flesh and spice-laden veins, so I smiled more naturally and replied, "That's my speciality... I can do either lather shaves, or just clipper—"

Somewhat reluctantly, the taker replied, "No, not just clippered ... my boyfriend, he has this thing about skin, y'know... all over."

The words "my boyfriend" were an explanation—and a challenge. Most of my female customers went for the Powter or O'Conner look because their lovers were spending too much time ogling those chrome-pated, unattainable TV visions, and judging by how few of them returned for touch-ups, either their boyfriend took over the daily shaving chore, or they realized that wearing a wig on the job was a consummate drag (the salon also sold wigs on the side), and went back to doing the hair-spread-over-the-pillow thing, and to hell with what Boyfriend thought. But there was always the possibility that Boyfriend might like an entirely naked girl, too, so as casually as possible, I assured her, "I'll do a close job, so your boyfriend should be pleased ... you said 'all over,' didn't you? As in—"

At that she blushed; the rush of blood coming to her cheeks made my mouth water and my labia jerk

so hard I had to (albeit casually) cross my legs as I leaned back against the counter top behind me. Reaching up to toy with a thick curl of hair for what might be the last time in a long time—depending on how pleased Boyfriend was with my efforts—she licked her lips and said softly, "I was embarrassed to ask out front, but I figured since there's the word 'Tails' in the name of the shop ... he'd like it ... y'know, down there, too. He said he'd like to be able to—" at this she blushed deeper, until the reddish glow seeped into her make-up free eyelids "'see the rose as he's plucking it.' I know it sounds weird, but ... well, he's given me a lot of flowers, on my birthday and on our anniversary of when we met and all, all of them these pink bud roses ... and what he has the florists write on the cards can be a little, y'know, embarrassing, especially when they deliver the flowers to the bank where I work, but ... you know. It's not like it's real cool to send a guy a rose in a bud vase"

Her words took me back to my first few nights with the one who took *me* into this world, the same world I was aching to bring her into with a few styptic-stinging kisses. I'd been spread open before him on his bed, a pillow placed beneath my behind, and he'd been tracing the contours of my glistening pinkness with a lazy forefinger, telling me, "Do you ever look at yourself, opened like this, in a

mirror? I thought so ... have you noticed, how each lip curls just so, like the petals of a bluish rose, until they meet in a tight cluster right ... here?" With that, he rubbed my clitoris in a feathery, semi-circular motion with one finger, while using the other nail-down to trace a thin jagged line from my navel to my slit, which became a reddish inkless tattoo for a few seconds against my growing-ever-paler skin. "See how you'd look if you were a rose? 'Rose is a rose is a rose is a rose?'" he asked, indicating the carmine "stem" he'd drawn upon my flesh.

I'd had to arc my neck at a slightly painful angle (mainly it made those tiny incisions there hurt) to see his handiwork, and even then all I had the power to do was moan a soft assent before the full force of the orgasm swept me away into a crimson, eye-lids-closed private world...

One slightly deeper whiff of this woman's scent told em that Boyfriend couldn't be my old sanguinary sweetheart—all vampires have a special, very undefinable sweetness, like old chocolate, in their blood—but I felt a certain kinship to him anyhow ... even though he would soon be my rival.

Poor man ... I can understand why you want to see all of her, touch and taste and caress it all... even if you're willing to forgo the ripple of hair under you hands, or the moistening mat of curls surrounding that soon-to-be-plucked rose....

A little too much time had gone by while I was bathing in the sweet come-like stickiness of my memories; the girl's face became slightly anxious, and she asked timidly, "I know it *does* sound silly ... I mean about the rose—but could you do it?"

Not letting the sigh I felt escape my lips (although I couldn't resist the urge to lick them), I replied, "Of course, Would you mind slipping out of your shorts and panties? It'll just take me a couple of minutes to get ready."

While the young woman slowly unzipped her shorts, her face wearing the expression of a thirteen year old reluctantly disrobing for the first time in gym class, I prepared the small rolling table with the clippers, five-pack of razors, shaving foam, and scissors. Then, as she wiggled out of the shorts to expose her pale green, lace-trimmed cotton briefs (I could make out the plastered-down arabesques of russet curls over her mons), I placed the long fresh towel over the seat of the barber's chair in readiness for her. As she watched me pat the white towel down on the leather seat she gulped, but stuck her thumbs down into the lacy waistband and—with her her heart pounding so hard it made her left breast quiver infinitesimally—pulled down her panties, then gracefully stepped out of them. With a schoolgirl-like neatness, she bent down, knees

together, and picked up the briefs and shorts, and placed them on the stool where I usually sit between customers.

You must really care about your boyfriend to put yourself through this...I only wonder if he'll be so grateful once I get through with her, I asked myself as she sat down primly on the barber's chair, legs tight together, and arms gingerly placed on the padded armrests. Barely able to suppress a smile, I picked up a drape, put it around her neck (the sensation of her hair sliding over the tops of my hands as I secured the Velcro tab behind her long, thin neck was like silk rubbing against my most sensitive parts), then said, "You'll have to open up ... I can't do a full job otherwise."

For a second she just sat there, looking at her draped body and exposed, tousled head for a moment in the numerous mirrors surrounding the chair, a shocked expression on her face... until she caught on, and obediently parted her legs, so that the drape tented over them above her spread thighs. The funny part was that she had the drape hanging over her snatch....

Before I picked up the clippers, I gently gathered the hem of the drape in my hand and pulled it upward, until the extra fabric was bunched in her lap. Across the room, she was reflected in all of her waving, curling, sunset-varied hues, with the deep

pink rosebud center of her right in her line of vision; from the sharp intake of breath she took, I realized that she'd never seen herself so open ... or so vulnerable.

"It won't ...y'know, pull, when you cut it... will it? Going against the grain—"

"You'll be surprised how good it can feel," I assured her, before asking the standard question at the Heads or Tails salon. "Which do you want done first, heads or—"

"Uhm... I never thought about... Maybe my bottom ... no, wait, better do the head," she finished reluctantly; most women go that route, even though it seems illogical. I suppose it has to do with the thought of someone touching the private parts ... especially when no woman has done so in such intimate circumstances before.

And like most first-timers, she kept her eyes closed once I switched on the clippers. Usually, shearing takes about ten or fifteen minutes, if you're careful, and feel for any unexpected bumps or irregularities on the skull. But doing this one, this taker, took a full twenty minutes. With each slow, cautious movement of the clippers, another drift of sun-kissed hair filtered down, caressing my shins before it rested on the floor at my feet. The reddish stubble still caught the light well; from certain angles it resembled the nap on velvet, with a pearl-like white base.

And this close to her scalp, her bare neck, the
odor of fresh spicy cinnamon was overpowering,
achingly intense ... but I knew I'd have to wait for
my chance to savor her. Clippers seldom cause nicks
serious enough for a stinging kiss

Once the last of that rippling, gorgeous hair was
liberated from her scalp, I tilted the chair back-
wards, so that her head rested on the sink drain,
and—after warning her what I was going to do—
ran warm water over her scalp, prior to lathering
her up. By now she was beginning to relax; a thin
smile even played on her lips. But she still wouldn't
open her eyes, not until I'd massaged her wet scalp
for a few seconds, and she fluttered her eyes open
before asking "Is the cream heated? My boyfriend,
he does that before he shaves—"

"Naturally." By now, I was shaking so much in-
side I was afraid I might cut her for real, but once
I picked up the can of heated cream and sprayed a
dollop of it onto my left palm before smoothing it
onto her scalp in a thin layer (too much lather and
you can't see the grain of the hair —and shaving
against it can be painful—but too little, and the
razor pulls), my pre-vampire days hairstylists'
auto-pilot took over. Once she'd been fully lath-
ered, the foam barely covering the velvety bristles
of her remaining hair, I washed off my hands, then
pulled on the fresh pair of rubber gloves necessary

before I could pick up one of the new razors from
my little table. Even before I'd gone permanently
nocturnal, I'd been the smoothest shaver at the sa-
lon; the trick is applying just the barest amount of
pressure against the gently rounded surface.

And this time, when she closed her eyes, it was
purely in ecstasy; the heightened rhythm of her
breathing was unmistakable, even under the cling-
ing drape. Whether or not a female customer I was
shaving was an intended meal or not, I loved to see
that blissful look on their eyes-closed faces as the
gently bending steel caressed and cleaned their
scalps; I suppose it's the look men strive for on the
faces of women they're fucking—that away-from-
it-all gratified expression.

I was so taken with stealing glances at her face
in the surrounding mirrors as I worked, in fact, that
her head was smooth and pearl-like before I'd had
a chance to inflict a deliberate, although albeit mi-
nor dripping wound. Her eyes were still closed, so
I debated whether or not to run the razor across her
delicately veined white flesh once again, as if seeking
stray hairs, but it would've spoiled the moment, some-
how. It was my fault I'd missed my first chance at her;
going back to correct my omission would be too cruel—

She's just a taker, not anything that special to
you, I sternly reminded myself as I lowered the
chair for a second time, to wash off the last bits of

cream from her head, prior to lathering it up with
an aloe-based shampoo. That she'd moan when I
worked the foamy lather around her smooth, moist
skin was a given ... but what wasn't so much of a
given was the way that low, purring moan made me
reflexively arch my pelvis, the muscles in my inner
thighs twitching in time to her barely voiced cries.

That was when I realized that her heretofore
unnamed boyfriend was definitely going to get
more than he'd bargained for when he sent her
here. After all, roses and pearls are equally beauti-
ful to more than one beholder....

Once I'd toweled her off, and then slathered a
fine coating of the most delicately-scented oil I
could find on my counter onto her shorn pate (I
didn't want to risk obscuring that heady cinnamon
bouquet which all but radiated from her newly bare
skin, like shimmers of heat coming off a smooth
road in the summer sun), she timidly reached up to
run a smooth hand over her satin-fine skin ... then
gave me an unexpectedly wicked grin, her eyes
twinkling.

"I didn't think it'd feel like this," she whispered
throatily, her breasts rising and sinking deliciously be-
neath the drape, "I'm glad I left the best for last....."

That a customer got into the whole bareness thing wasn't unusual, but the transformation from schoolgirl shy and demure to completely relaxed and ready for more in this particular customer-cum-taker was enough to make my heart lop so crazily I was afraid that it would stop from the extraordinary effort. It was only then that I glanced down at her waiting quim; the image of roses after the rain, when the sunlight (a still poignant, missed memory for me) hits the petals, revealing the subtle blend of colors on each petal came to mind ... and this time, the scent of that brown, powdery spice, mixed with her own rose oils, was all but intoxicating. I had to steel myself against simply going down on her then and there, and tearing into that delicate wrinkled flesh with incisors bared openly.

Now my problem would be restraining myself; it would never do to drink too deeply, especially from such a nest of tender folds and hidden creases, lest her boyfriend (*and my enemy,* I decided) notice my handiwork too quickly before she left him.

That she would eventually leave him would now be a given; for a brief moment I wondered if my vampire master, he of the no-name nightspot so many years ago, had known that I'd end up leaving my previous boyfriend, as he looked and spelled and wanted me so very deeply, with a yearning beyond reason, even beyond basic desire. (Once, he'd

told me that my "scent of dark coffee" was like a syrup cascading down his throat....)

But still, he'd been so intuitive to her potential shorn beauty, and so eager to witness that naked splendor, that this act of taking would haunt me ... even as it fulfilled me in a way no palm pumping mere *man* could fully understand.

Putting on my best, most professional face (at least for the moment), I switched on the smaller set of clippers and let my hand be guided by the individual mounds and deep valleys of her flesh; once I asked her to spread her legs out wider (I'd already lowered her chair to a reclining position, the better to see her curl-hidden petals), but apart from that, neither of us spoke—or had need to. Clipping the mound of Venus is trickier than clipping the scalp; the area is tighter, and more springy under the clippers, but this time around, gathering up my concentration was an almost super non-human effort.

Freed of the damp ringlets and tufts of russet hair, her mound was a mottled pink-white (from the pressure of my fingers as I spread the flesh to accommodate the clippers), but when I applied a small disposable make-up sponge (sea sponge; it has a rougher, more French-tickler-like texture) dripping with warm water to her stubbled flesh, it soon turned an even, conch-shell pink. I couldn't resist pulling aside her inner labia, to expose the

glistening slick skin within to the light, and was rewarded with a subtle upward thrust of her pelvis. That she was enjoying this gratified me, almost as much as taking a sip of her blood ... *almost*.

The lathering was dream-like in its slowness; up, down, and around the tender, sweet-scented flesh (by now, her own unique scent formed a heady counterpoint to her blood-bouquet), until the patch of foamy white was fully covered up to the tips of the stubble. Taking up the first of two fresh razors (sharpness is essential... and not just for my own vampiric purposes), I freed her flesh from the coating of foam stubble and drying foam, until she was almost entirely naked, more naked than she'd been at birth, in all likelihood... save for a last tuft of hair I'd left untouched, close to the gently rounded spot where the tip of the mount meets the tuck of the flesh hiding her clitoris.

True, that tight curve was the most difficult place to shave, but that wasn't why I left it for last. Unless I became as animal-like as the bat most non-vampires erroneously think we can turn into at will, I'd have to be cautious now ... lest my actions become too obvious, too potentially frightening...

"Could you be very still now? This is the tricki-est part... otherwise I might nick you." Getting the words out without bending down and biting and sucking and drinking her in was difficult, but she

didn't seem to notice that anything was out of the ordinary.

As she spread herself even wider (could she be into gymnastics? I wondered), so that the last daub of nearly dried foam covering that dime-sized patch of remaining hair was almost perfectly level before me, I had to release some of the pent-up desire in me ... if not my thirsting desire, then my sexual wanting.

Using both hands, I gently fanned my fingers over her taut lower belly, her tight thighs, not letting myself touch her exposed petal-softness, her intricate folds and crevices of glistening flesh, until I was sure that my hands wouldn't shake too much. I only needed a tiny nick, not a bloodbath... even though I would have loved to have felt her cinnamon warmth coursing over me in hot, spurting runnels

Taking up the second of two razors I'd used on her, I let the sharp steel bite ever so superficially into her pale skin on the downstroke. I don't even think she felt the nick, it was so slight, but my mouth flooded with burning saliva when I saw the tiny dark pearl of blood rise up in all its spicy-warm splendor.

"Uh, oh, I drew a bit of ... lemme get the pencil," I mumbled, before grabbing the styptic wand off the little table ... and then clutching it so tightly

in my fingers that it bent out of shape as I knelt down and ran my tongue over the welling beads of ruby sustenance, before my incisors bore down on the pliant, perfumed flesh of her outer labia, her mons, her inner thigh....

For a moment, a deeply shamed, yet animalistically exalted moment, I felt a stab of fear-pleasure—here I was, being so obvious, so greedy, and with an uninitiated taker. But in the next moment, as I stopped my inhalation-like feeding, I realized that she was moving her pelvis and hips in time with my movements, my feasting on her very inner essence.

Sated enough to stop what I was doing, I guiltily wiped my bloody lips clean with the back of one hand (then licked said hand with a fly-flick of my tongue), before standing up between her still-splayed out legs, and letting my gaze meet her own. Reaching down with her right hand, she gently touched the place where I'd been sucking out her blood, gave me a smile, one that did reach up to those memory-of-sunlit-leaves green eyes of hers, and then said softly, "I suppose I can tell my boyfriend that even my rose had some thorns ..." before beckoning me back to sup once more on her glistening feast between her outspread legs.

But the best part of what she said was the way she made "boyfriend" sound so casual, like something ultimately fungible after all....

* * *

Later, without needing to ask, she simply agreed to come to the salon on a thrice-weekly schedule, for "more of what you did tonight." I didn't ask her her name; eventually, she became Rose for me, and that was all either of us needed. But that first night, as she dressed and covered her pearlescent scalp with a scarf she'd brought along in her shorts pocket, I busied myself with a little gift—a token of future losses, actually—for her soon to be ex-boyfriend.

It's funny, but if you take those pink and red colored specialty condoms (like I said, the Heads and Tails offered occasional "extras") and—after opening the packages—twist and bunch them just so, then attach them with plastic-covered twist ties (green ones, naturally—we keep them on hand for securing garbage bags full of clippings) to those wooden sticks we use to stir hair dye, they'll look an awful lot like rosebuds.

Maybe her boyfriend did find my gesture touching (Rose never felt the need to say, later), but from my point of view—not knowing just how faithful he might be—I was only protecting my investment against blood that stank of moldy grapes and bread long gone stale.

The Hunger

Warren Lapine

Hunger consumes me, pain beyond comprehension. To think, I entered the ranks of the Nosferatu willingly, nay, eagerly. Immortality at any cost. I could not have known the price that I would pay.

How could a man reborn in 1890 even imagine the horror of today; the first hint of disaster was still more than fifty years away. Had I known had I even suspected, I would have stayed among the breathing.

To live forever, it was too strong a dream, too much a temptation. I followed you, Janette, eagerly to the grave. And who wouldn't have? You were a beauty beyond compare, a lover with unlimited passion, a companion to spend eternity with.

Do you remember the first time we made love? I didn't know than that you were Nosferatu. You seemed so warm, so alive. I couldn't have known that you were straight from the kill; that you had killed because you desired me. When fresh blood pumped through your veins, no mortal could have resisted you. I can still remember the way you

43

smiled as you told me you loved me. Yes, I remember, I remember everything. You said, "I love you," and then you reached out for me. I took you to my bed and we undressed, ever so slowly, in the candle light. You were exquisite, long brown hair, beautiful blue eyes, delicately structured face, and such inviting lips. I could not resist you naked there before me. Looking back on it, it seems to me that I held you for hours, enthralled by your beauty and the feel of your skin. And when I mounted you and felt your moist warmth surround me, it was more than words can describe. At that moment, somehow, I knew that we would spend a lifetime and more together.

I remember how your moans of pleasure became louder, the way you began to thrash beneath me; and I will never forget looking into your eyes as you opened your mouth and revealed to me your fangs. I should have been frightened, I should have run away, but the look of love in your eyes held me, it told me that all was well, I could trust you. And when you said "Come give me your neck," I didn't hesitate. Certainly there was fear, but that was part of the allure. The thought of eternal damnation seemed insignificant in comparison to your beauty. It seemed that the fangs that would be my death would also be my salvation. I didn't know that you planned to make me Nosferatu, but I would have

surrendered up my soul to you even if you had not. The burst of perception that I gained when your fangs penetrated my neck will always live in my memory. Suddenly, we were truly one, not just pathetically striving to be one as mortals are when they make love, but truly one. All the veils were ripped aside and we were granted a view into one another's souls. What I saw shook me to my core; as much as it terrified me, it aroused me, making me wish to share eternity with you. I wanted you to take every drop of blood I had, leaving me nothing. I'll never know how long it lasted. It was such ecstasy, and you knew then that I was yours for eternity.

Afterwards, you helped me find my first kill. I was almost helpless, overcome as I was by my heightened senses. Everything seemed so beautiful and so alien all at once. You brought her to me. Truthfully, I cannot remember what she looked like, but I will never forget when my fangs parted mortal flesh for the first time. I felt the beauty of her vulnerability, and yes, I felt her desire for death at my hand. And then you joined us. I felt your presence as your fangs entered her flesh. Our victim seemed insignificant, serving only as a medium to intertwine our souls. With each beat of her heart, the ecstasy of our union grew stronger. Until finally, her heart beat no more. With her death,

we were bonded more closely than mortals could ever hope for. A bond that would hold us together until the end of the world.

My love, where are you now? Have you found rest, or do you suffer, as I do, somewhere amongst the ruins? If only we hadn't parted. No, I could not wish that on you. It is better to think that in the end, you found the peace that I was denied, that you did not escape the holocaust that devastated the planet.

If I believed in the power of Heaven, or Hell for that matter, I would pray for you. It seems to be too late for me. I am here and all else is gone. For a brief moment I thought that the world could escape this fate, that mankind would unite as brothers and vanquish all ours fears. Alas, that moment faded.

It faded with the hunger that spread across Eastern Europe, after Bolshevism died. Freedom was no match for hunger, I understand that now. The hungry seized power, and tried to make the rich feed them. When that failed, they destroyed everything. Almost everything.

Why did you have to spend that day away from me? In over a hundred years we did not spend more than a handful of days apart. How could this have happened to us?

After the world ended, I searched for you. I went to all of your favorite places. If you live, then you know that I did not find you. But I tried, my love, I tried. I can not bear to think of you trapped somewhere, being consumed by a hunger that you can never feed. No, I prefer to believe that you were spared my fate.

If only I could think of a way to end this existence, I would follow you. If this were Hollywood, I could impale myself upon a wooden stake. But alas, I must accept reality, wood has never been sufficient to kill a Nosferatu. No, it was only used to pin us in our coffins, so we could not wander about the mortal world by night.

My only hope of escaping this hunger, lies with the Sun. If I could expose myself to it, then I could die. But even that is denied to me. Will this nuclear winter never end? Will the Sun, that I lived in fear of for so long, once again caress me and send me to oblivion?

I don't know. Rummaging through what is left of the world's libraries, I have found that man knew little about nuclear disaster. Some accounts said that the winter would last for a year, others that it would not happen. It has been two years, and still the winter has not broken. The Sun refuses to shine.

Two years without sustenance. Agony beyond mortal comprehension. And so, as it must be, I think of you, as I await a dawn that may never come.

Wanting

Amelia G

I was surprised when the DJ said that last rockin' number was off the new Motley Crüe album. Gotta love that nouveau underground sound. Well maybe. Then the DJ added that Madison is in the video for "Hooligan's Holiday", the song we had just heard. Like anyone in this part of the country knows who Madison is. Made me wish we got cable around here though.

I was guiding my monstrous old Caddie along the route to the grocery store, when the DJ turned on The Cult's "Fire Woman." I blame that—maybe credit that—for everything that came after. I gave a passing guy in a pickup the one-finger salute just in case he was thinking my car was too big for a woman. Never look down on anyone in a vehicle big enough to take you out without slowing down.

I'm old enough to remember seeing Southern Death Cult live. I was spending three years abroad. Pissing my parents off. They'd pissed me off with their reaction to 'Cilla. "It's not your fault, honey.

49

It's a sickness." Please. I'd charged the plane tick-
ets on my mother's platinum AmEx and made my
dramatic gesture. Such a rebel. Ha. At 32 now, I can
see that if I had really loved 'Cilla, I would have
stuck around. But hindsight is always 20/20. Be-
sides, true drama would have been a one-way
ticket.

As I got off the country highway and turned
onto the street that led into town, fucking Pearl Jam
came on the radio. So I turned it off. The money
had just about run out so I knew I was going to
have to return to the world soon. Contract out with
Oribé. Do fashion or something. I had made the
transition from Goth to glam without pain. I may
be the only person on the planet who enjoyed "Fire
Woman" as much as "God's Zoo". But the thought
of doing makeup in a grunge world made me ill.

A comfortably warm, clean springtime evening,
the sort that can only be found in upstate New
York, was just beginning to settle in around the
town. I parked outside the market.

I noticed her immediately after stepping across
the threshold of the store. Maybe it was her coat.
I'm not sure. I was only slightly chilly in my tank
top and cutoffs, but she had her shoulders hunched
under a dirty leather trenchcoat. She was pale.
Sickly-looking really. But the shock of recognition
was sharp and fast. There was no mistaking the

perfect arch of those thin eyebrows, those unnaturally angular cheekbones, the thin upper lip contrasting with her pouting lower one. Begging for deep red lipstick. Begging for something. She was small and thin and ludicrously out of context next to the fresh strawberry display.

"Danielle?" I asked incredulously, although I knew it was her.

"How do you know my name?" the waif asked.

My heart sank. I'd only done her makeup a few times, but she had been more a part of the whole glam thing, while I'd hung out mostly on the Gothic scene. There really was no reason she should remember me more than a decade later. "You are Danielle Hazzard, aren't you?"

She smiled thinly, but with humor. "Danielle Jones now really. Did I know you then?"

I held my hand out to shake. "Rachael Bloom. Pleased to remake your acquaintance. I, uhm, did your makeup for you a couple of times. When you warmed up for Hanoi Rocks."

When she shook my hand, her hand was cool to the touch and she left it in mine a beat longer than appropriate. "I do remember you now. It must have been your longing. Opening for that band was so terrific. So terrifying. They were so good. Omnisexual and androgynous. Michael was so beautiful. Is so beautiful. Almost enough to make you change your mind." Her voice was low and not quite ac-

cented, but not very American either. I wondered if the Michael comment was a test.

I took my hand back and I was about to hold forth on my opinion about standards for beauty being the same, regardless of gender. Then I caught sight of the shopkeeper watching us. I pretty much kept to myself, but the last thing I needed was to arouse any more comment than my reclusive lifestyle already did. "Would you like to go have a drink or something?" I asked Danielle.

"I don't really like to eat anyway." Danielle gestured around the little market disdainfully.

I couldn't remember what I'd needed to pick up for myself. So I led her back out to my car.

"The black Cadillac. Is that one yours?" she asked.

"I'm a sucker for nice tail fins," I said, mentally raising my estimation of this woman who seemed somehow conjured from my past.

I opened the passenger door for her and maybe it was my imagination, but it seemed that she wiggled for my benefit when she replied, "Nice tail fins are important." Not that I could really tell what her ass was like under that long muddy leather. It looked like she'd been slopping pigs in it. "Aesthetics in general are important," Danielle added after we were both seated in the womb of my big black Cadillac. Funny words, given how she was dressed. I was actually concerned about the mud she was

tracking into my car. I swear it was even in her hair and everything.

I started up the powerful engine of my car and felt it come to life, rumbling reassuringly beneath our seats. The thin delicate creature sitting beside me turned and said, "You didn't go by Rachael Bloom ten years ago, did you?"

I blushed. "No."

"What name did you use?"

I guided the car back onto the main street of town. Drove past the antique store and the sole sad little bar. There were four dusty pickups and a beat-up Pontiac sitting outside and we could hear male laughter, even over the purr of my Caddie's motor. A teenage boy was climbing out of the least dust-covered of the pickups. "This is the only real place to get a drink in town." I pointed.

"Looks charming," she said sarcastically.

I stopped the car but did not turn it off. "They water down all the good stuff," I told her. "I've probably got a better bar at home and I never even entertain."

"Let's go to your home, then." I looked at her, but her expression was unreadable.

I put my metal monster back in motion. "Are you sure?" I said. I pointed at where the teenage boy was going into the bar. "He's kind of cute." I waited for her response. Testing. Not even breathing.

She watched the boy's faded blue jeans and red plaid shirt with the sleeves ripped off, watched them disappear into the bar. "Don't they have a drinking age in America any more?"

I exhaled. Still unreadable. "It is a small town. The barkeep pretty much overlooks everything. It's hard enough for him to stay in business as is. Besides, the sheriff is his brother-in-law."

Danielle said nothing. Just hunched her shoulders and held herself.

"What do you want to do, Danielle?"

"Let's go to your home and sample some of your fine bar. I could really do with a shower too. Then maybe you could do my makeup again."

Images from the last time I did her makeup flashed through my head. I could barely see the road as the Caddie took us up the winding dirt road to my house on the hill. Danielle had been in this band which played music too bouncy to totally appeal to the Gothic audience. But she was a Gothic wet dream to look at. She never stopped moving during a show, never ran out of energy so long as the crowd wanted more. She still looked cool, but it was odd to think of this sickly-looking woman as that hyperactive girl who had seemed to feed off her audience's excitement, strutting across the stage in nothing but black netting and bat wings.

I had hoped I'd get to do her wings, but she did her own costuming. Just liked getting a hand with

the painting part. I had loved accenting the planes of her angular face, but I had almost died of embarrassment when she had me rouge her nipples. My housemate who had gotten me backstage—she knew the guitarist—had almost died laughing. Danielle's perfect high round breasts did show in that outfit though. And the rouge had made her nipples stand out through the black netting.

"So what name did you go by in England?" Danielle interrupted my reverie and I blushed at what I'd been thinking about.

Then I blushed at what I was about to tell her. "Uhm, Razor. Razor Flower."

"That's pretty."

"Yeah, pretty pretentious."

I stopped the car and Danielle gasped. "Is this your house?"

"No, I live in the servants' quarters." She looked at me, searched my face. "Yes, this is my house. Real estate is pretty cheap around here. Joys of living in the middle of fucking nowhere."

The gravel crunched under our feet as we walked across the driveway to the front steps. I let us in and showed Danielle the bath. It was a beautiful old thing with claw feet, but I'd had the plumbing modernized so the water could be wonderfully hot. And I had an eighty gallon tank so I never ran out of hot water. Different luxuries are important to different people.

I had hoped she would be naked when she got out of the tub and I waited for her in my bedroom. The country sun was setting outside my windows as I laid my zillions of little jars of makeup out on the little dressing table with the antique three-part mirror. I had just brought out two glasses of ice and a couple of bottles of my favorites, when Danielle entered the bedroom. She looked a thousand times healthier even though she was technically paler without all the dirt on her. Her hair was blacker and longer than I had realized.

I wished she was not wearing my huge fluffy white terrycloth robe, but I forced myself to take a couple of scarves out of the dressing table drawer so I could pick one to tie her incredible hair out of the way. Forced myself to act like playing with makeup a little was all I wanted. At least she left her awful muddy clothing in the bathroom.

Her skin was warm from the bath as I ran my fingers over her face, using a combo of Bob Kelly purples and greys on her eyes. They were already big, but the makeup gave them a knowing look. I rimmed her eyes in blackest black. All makeup artists have their own little biases. Mine happens to be that I believe black eyeliner is the only one that counts, the only one that is ever genuinely in fashion.

As I worked, Danielle made casual conversation. We talked about how much we had loved the dark bondage-inspired fashions of the early eighties,

about how much we hoped that look was coming back in style. She asked me how I could afford such a mansion. Even in upstate New York. I surprised myself by telling her the truth. About my trust fund. About the lawsuit with my parents. How they'd said I wasn't competent and how they just hadn't thought about what ten percent means when they'd offered the judge their proof.

"That's great," Danielle said, "the judge even awarded you punitive damages."

I used my index finger to stroke the Chanel red lipstick onto her smiling lips. It might have been my imagination, but I thought she licked my finger when I added the X-Rated lip gloss as a top coat.

I guessed it wasn't my imagination, though, when those shiny red lips moved to ask me, "You should put some blusher on my nipples. Nobody does that like you do." She let my robe fall open just enough to reveal two coral circles tipping two breasts that were far too high and too firm for the age she had to be. Maybe she'd had surgery. She didn't seem like an exercise freak.

I wanted her to admit she wanted me before I risked anything so I just started to rouge her nipples with a nonchalance I had been unable to muster at 21. "I thought you said you didn't remember me."

She moaned softly as first her left nipple and then her right grew stiff and hard between my

blush-slick fingers. "I remember you. I guess I just wasn't thinking clearly." I decided that counted as enough of an admission of desire and I leaned forward and buried my face between her breasts. She smelled like gardenias, like my soap, and she moaned again when I kissed her there. "I'm usually fuzzy when I've just woken up," she added, "I like to sleep until there's really a need. Really a need to do otherwise."

There was almost an electric shock when our lips met. I'd wanted to kiss her for so long. I'd wanted to kiss her so badly. Her tongue explored my mouth like a wild intruder, forcing my tongue back out from between her lips with her strength. She held me with a fierce urgency, tearing my tank top up over my head and dragging my shorts down to the floor, following them with my little black silk panties.

"You've smeared your lipstick," I said when we finally came up for air. I reached a finger up to fix it.

"I don't want you distracted from your pleasure. Can I tie you up?" she whispered. Danielle's breathing was already heavy. It must have been even longer for her than it had been for me. "Please," she moaned, "if you like bondage, I know you'll like what I want to do."

"Okay." I nodded and picked the scarves up off the dressing table. Some part of me knew that this was what I had brought them out for. That this was what I wanted. I felt incredibly self-conscious and

aware of every part of my body as I walked naked over to the double bed. Danielle, still in my terrycloth bathrobe, followed me and I handed her the scarves. I lay down across the country-style quilt and held my wrists up to the red wood bedposts.

The bonds she tied around my wrists were quick but gentle. I tested them lightly and realized that the knots were perfect. I was firmly secured, but my blood would have no problem circulating.

"Do you want to be mine?" she whispered huskily. I nodded.

"Do you want to be mine?" Her tone was sharper this time.

"Yes. Yes, I want you. I want to be yours."

"Give me your leg," she said, gripping my ankle. I felt so vulnerable once she had me tied spread-eagled on the bed. The setting was so wholesome, so countrified. And there we were, two fair-skinned, dark-haired creatures of the night. How had I ended up in the country.

She stroked her hand up my thigh.

"Oh. Take the robe off."

"Later." She took an ice cube out of one of the pair of glasses I had intended to put drinks in. She ran the ice up the thigh she had just stroked. "Do you like this?"

I moaned.

She ran the ice cube up my thigh, over my hip, along my tummy, up my rib cage, and circled my left nipple. It was instantly hard and aching. She ran the ice cube across my cleavage to the other nipple where it melted.

Danielle pulled another ice cube out of her glass and, with no warning, plunged it into the place of secret need between my thighs. "Oh." I was so hot, it started melting fast. She took another piece of ice and ran it teasingly over my clit. I almost screamed, it was so intense. She ran the corner of the ice up over my body, then back down teasingly across my aroused clitoris, down across my lips, then lower. A cold damp puddle was forming on the quilt beneath my ass. I shivered with both chill and arousal.

She put a new ice cube into me. "Do you like that?" she breathed.

"So cold, so cold."

"Do you want me to stop?"

"No, no, don't stop." I thrashed around on the bed, my pelvis reaching for her. Her eyes were alight with a mischievous glint. Her closemouthed smile driving me mad with lust. "Don't stop," I begged her, "I want you to go on. Take off the robe."

"Later." Danielle stuffed another ice cube into me. I was so so hot and they were so so cold. She was running another piece of ice from side to side, thigh to thigh, when she suddenly dropped her head, hiding my pelvis beneath her ebony hair. Her

tongue burned on my clit and this time I did scream. Her name. Incoherent sounds. Then I think her name again. The top of her rough tongue scraped a sweet circle of intense sensation and I was coming so hard, I nearly blacked out.

Danielle lay down next to me on the crazy patchwork of the flowered quilt. She held me, but she made no move to untie me. "Do you always come like that?" she murmured. She sounded sort of sated herself.

"Only when I'm as turned on as you make me." We lay together for a moment. Then I asked, "did you come too?"

"Mmm-hmm," she replied, smiling lazily. "You're so responsive. It's really beautiful. It's really exciting."

"You'd like it better with your skin on mine," I said. "I want to taste you."

"You promise it will be okay," she said. The last remnants of sunshine streaked through the lace curtains, highlighting her glossy tresses. She looked pretty healthy now too. Still pale, but not in a bad way. And I wanted so badly to see her naked. So badly.

"I'm sure it will be okay," I told her as firmly as I could manage while tied to the bed.

She put her feet down on the wood floor and stood. Then, with a shy look, she shrugged off my white terrycloth robe to expose the black leathery

wings I had known she was hiding. "Are you sure it is okay?" she asked me.

"Let me prove to you how okay it is," I told her. "Let me please you."

"You please me already," Danielle answered, but she crawled up over me anyway and placed one white white thigh on either side of my head.

I lifted my head up off the pillow and tasted her. I've been with a lot of women and I'd heard honey metaphors before. Always thought they were stupid. But Danielle, Danielle tasted like candy apples. "You're so sweet," I spoke into her mound.

"It really is okay with you." She laughed a small giggle of freedom and then moaned.

"It's okay," I groaned between licks, "you're so beautiful, so sweet, so, so, so, I couldn't want you more if I tried." And I settled into pleasing her in earnest. All too quickly her little moans turned into a violent body-wracking shaking. She slid back down my body, her wetness affirming my power over her.

She enfolded us both in her dark wings and the leather was soft and smooth and supple and alive, not like her coat at all. I thought maybe I should be freaked out or something, but the surprise never came. Motley Crüe doing an industrial-influenced album was more surprising to me than her wings being real. "I'm all turned on all over again," I told her. "Maybe not again. Maybe just still. I want you."

"What I want is your wanting. Do you want me?"

I opened my eyes and looked at her, her thin frame somehow managing to loom over me. "Yes, I want you. More than I've ever wanted anyone else."

She smiled. Open-mouthed. Showing her fangs for the first time. The fangs I had known were there. "Are you going to drink my blood?" I asked.

"No, silly." She threw her head back and her long heavy dark hair flew up into the air behind her and cascaded back down over her shoulders like a black waterfall ending on my breasts. She laughed and it was the most beautiful music I had ever heard. "What I need is your wanting. Just your wanting."

For a moment, I was almost disappointed, but my body always knows what I really want. And my body throbbed for her touch. "I want you. I want you so much. Please touch me. I'm almost there."

And, smiling, she reached down between my trembling thighs and stroked me in that last gentle circle I needed to put me over the edge.

My orgasm broke through me. The release was incredible, but the wanting didn't go away. And neither did Danielle.

Predator

Raven Kaldera

It was raining hard, and the poor visibility interfered with Val's driving. Reyna watched her struggle with a sharp turn and felt the jolt as the brakes slammed them back in their seats. A car much faster and sleeker than theirs cut them off and slewed by, its jets churning up the water. Val cursed and glanced at Reyna, who was still sitting like a statue, unable to move, and the smaller woman's glance flinched away as if the sight hurt her. "Um, love," she began, and Reyna could hear the weariness and trepidation in her voice. "I haven't eaten since early this morning. Do you mind if I pick up some takeout? It won't take more than five minutes, I promise—"

"Yeah, sure." Reyna cut her off with a wave of her hand. Gods, what an effort it was to move. "Go ahead. I'll wait in the car."

"I could pick up some for you, I know you like Thai—"

She snorted. "The doctor said it wouldn't do me any good."

"I know, but you can still taste—"

"It's not worth wasting the money on." Her voice sounded dry and cracked to her ears. "Go on. You need it."

Val hesitated, reached over and gave her hand a squeeze, and then parked the car, slipping out into the wet night. Reyna was left alone with her shock and fear and the bundle of papers clutched in her lap. Her skin flashed back and forth from numbness to near-irritating sensitivity to her clothing, even though the leather jacket and boots were well broken in from years of wear. The shirt and kata pants weren't clean; Val had grabbed the first things she could find when the hospital had called to tell her that her lover and mistress was awake from the three-day coma. Reyna's short fingernails dug into her knees. Eighteen hours a day Val sat next to that prone and wired form, or so the nursing staff told Reyna on her way out. *Only went home when she dropped from exhaustion, and was back the next morning. People I don't respect might say it was only what one would expect from a good slave; people who didn't have the trust and love for each other to pass the exhaustive psychological testing necessary before becoming licensed as official consensual slaves and slaveowners. People who didn't understand how love and power could sleep in the same bed.*

"Of course, your marital status will be automatically dropped back to standard domestic partnership," the psychiatrist had informed her. "The government regulators feel that allowing someone to choose to be owned by an individual in your condition might be opening the situation toabuse." He obviously didn't wish to elaborate, but seeing the look of horror on Reyna's face, he'd rushed to reassure her. "I'm sure you can reapply in a year or two as long as you can prove you're following the no-harm guidelines. Now, we'll contact the local support groups listed in your information packet, and they'll send someone around within 48 hours to check on you and answer any further questions you might have about your condition. It's completely possible to live a long and nonharmful life with this virus. You just have to take your medication and stick to the rules. Do you have any idea where you got it, by the way? We have to ask that question because knowing transmission of the HCARVV virus is a felony, and the CDC will want to follow the disease vector."

Reyna had shaken her head no. Where she had picked it up? Who knows? As an experienced sexual sadist, you did occasionally see blood from the whip welts of the dangling submissives you were flogging into ecstasy. What could be more natural than to lick it off? Had it been that woman

Natalie, or Kern Haining, or that pretty boy lent her
for the evening by his master whose name she had
never been told? God knows. The psychiatrist had
continued, pursing his lips fussily between sen-
tences. "Contrary to popular belief, you can
contract the virus from someone who still has it
dormant in his system, who hasn't had it triggered
yet by brain death. The CDC ought to be pushing
safer sex guidelines."

Brain death. The truck careening out of control,
the painful thud as her hoverbike connected with
its fender, the crunch as her precious Falchion was
sucked under its jets—these were faint in her
memory, vague, as if seen through smoke and felt
through padding. There had been a flying sensa-
tion, and lightning-shot blackness as she hit the
pavement, and then nothing until she awoke in the
hospital ripping out tubes and wires.

The nurse who had walked in and screamed to
find her curled up in the bed nursing on the spare
bag of plasma hanging above her, its rivulets run-
ning down her chin and breasts in delicate tattoos,
that memory was clear. Within fifteen minutes her
room was sealed and the specialists were called. She
had never seen the SWAT team that must have sur-
rounded the wing while the shrink tested her with
careful questions, but she knew that they had pre-
vented Val, poor Val, tiny and dark and tough as

shoe leather, from entering until it had been determined that Reyna was not suffering from one of the rare strains that caused dementia. She'd been let go, finally, with a list of support groups and another of the Federal HCARVV Non-Harm Guidelines, a scrip for powdered plasma and another for the new drug, Vrykozine, that was supposed to dull the hunger. "Now this drug is legal only for you," the shrink had told her. "When used on non-HCSARVV sufferers, it's very addictive and causes illness. Don't give it to anyone else." As he left the room, it occurred to Reyna that he'd managed to talk to her for an hour without once using the word vampire.

The door opened and Val climbed back in, struggling with packages. "All set. I'll get you home in a jiffy, OK? Here, could you take this?" She held out a bag of what smelled like Thai food; Reyna's senses were suddenly incredibly sharp and she cradled the bag lovingly in her hands, turning it this way and that and discovering the wafts that meant fried rice with peanut sauce, or curried chicken. It didn't make her hungry, exactly; the scents were just a euphoric symphony that sang to her nose alone since her stomach was now deaf.

She was distracted by the scuttling sound in the other bag Val set down between them. "What's that?" she asked, reluctantly setting down the grease-stained bag of food.

"Well, I went into the pet shop, and..." Val closed the car door, glanced around guiltily, and opened the bag. There was a small plastic cage inside, and in it was a good-sized rat, sniffing the corners if its tiny prison. "I thought you might get hungry later. They sell them to feed to pythons. Don't name it."

Reyna turned her head and made a sound that was half sigh and half growl. "Val, damn it! I can't! The guidelines say I can't feed on living things, just the plasma. I'll start to crave it, and pretty soon I'll be attacking human beings." Squirming rats and dogs would lead to squirming human victims; it was against the no-harm guidelines, as was not responsibly taking the medications.

The dark-haired woman started the car. "How do you know?"

"It says so here, I guess...I can't afford to take the chance that they're wrong."

Val sighed. "Let's go to Canada," she said.

"What?"

"They won't let me be your slave here. So fuck them. We can go to Toronto, I know people in the leather world there—"

"Val, please, stop it." Reyna covered her eyes with her hand. "I can't just up and move. Besides, I can't be your mistress any more anyway. It would be too hard to resist...the kind of sex we have...I

mean, I might not be able to stop..." She didn't say
that she could smell Val's luscious iron-rich blood
from here, that the delicate vein at her temple was
far more tempting than that damn rat.

Her slave sniffed and wiped one eye. The stree-
tlights glinted off the ring of her metal collar.
"Don't say any more till we get home, love. You're
making me cry and I can't drive while I'm crying."
They passed the rest of the drive in silence, pulling
into their apartment garage without noticing the
rain had stopped. The light was becoming too
bright for Reyna's eyes as the clouds parted, so once
in the house she pulled all the curtains and then
shut herself in the bathroom.

Val got out a pan and threw some oil and chow
mein noodles into it to eat with her food, and be-
gan to chop an onion. Fortunately that thing about
garlic was a myth, she thought to herself, and then
realized that no food she could ever make would
nourish her lover now. It would go through her
undigested. A waste of money, Reyna had said. Val
was proud of her gourmet cooking; had been proud
to serve it to her mistress. After such a meal, she
would be rewarded by tight elaborate bondage of
silk cord or industrial chain, whipped by Reyna's
loving tortures into paroxysms of pain and plea-
sure. Tears from more than the onion's pungency
burned her eyes.

Her mistress came out of the bathroom and moved to the refrigerator, opening it reflexively. Then her shoulders stiffened under the leather jacket and she slammed it shut. Her depression rolled off her in waves. Val took a deep breath, nerved herself, and carefully moved the kitchen knife from the onion to her finger, slicing into the skin near the tip.

The pain caught her by surprise and she gasped aloud. Reyna turned from her funk to look at her. "You OK?"

Swallowing, the collared woman turned and held up her hand. "Oops," she said as the blood ran down her palm.

The taller woman took a step back. "Oh gods, Val, don't—"

Her slave advanced on her, holding out the bleeding finger. "Please, lover. Take it. It'll just go to waste." *And I want so much to make you happy,* her eyes pleaded. One scarlet drop hit the floor. The next moment, Reyna grabbed the injured hand in an iron grip and began to suck off the blood. Val gasped again and deliberately moved against her, pressing her crotch into Reyna's thigh. The taller woman smelled blood and sweat and the redolence of Val's cunt, and it was like magic, like humming, like climax, almost. Golden sparks danced behind her eyelids, and her mouth, finding no more blood

on the cut finger, moved to Val's lips and chin and then to her throat.

"Yesss..." Her slave's voice was throaty in her ear. "Take me, Mistress. Take me, lover. Do it." Reyna was holding her up now, almost off her feet, with a strength she had never felt before. Upper lip curled back spasmodically. Aching in the jaw like singing, or eating lemon juice, the soft skin of Val's neck, her lover, her slave, her precious treasure— and then the phone rang.

The spell was broken and Reyna pulled away, slamming her leather-covered wrist into her upper lip with a muffled cry. Val stumbled and caught herself against the table. Keening faintly in anguish, the taller woman flung into the other room, the door slamming behind her.

Val shook her head to clear it and lifted her hand. Where the cut had been was a tiny white half-healed line. She stared at the door that had closed behind her mistress, and then took her bowl of Thai food and went up to their bedroom, determination in every line of her body.

Reyna slumped to the floor in her workroom on the pile of cushions beside the easel and grabbed the phone. "Hello?" she growled. Her upper jaw still ached and her lip hurt where she had slammed it into her teeth.

"Hey there," came a tenor voice on the other end. Male. New Yorkish accent. "Taken that Vrykozine yet?"

The breath let out of her in a hiss. "Oh. You're the one they said would call, from the support group or whatever? No, I haven't filled the scrip yet." Feeling embarrassed, she hastened on, "I'm tired, and they gave me a lot of plasma at the hospital. I figured I'd do it tomorrow."

"Don't do it. Throw the scrip away. Better yet, sell it to a dealer. You can make a few bucks that way."

Her face froze in shock. "What! Who are—"

"Look." The voice cut her protest off. "Tomorrow, somebody'll come check on you. They'll be from the local support group, but they'll probably also be a government toad. You'll be able to tell them easy, because they'll stink to high heaven."

"Stink?"

"Like rot. Listen, that virus in you body is all that's keeping you alive, and it regenerates your cell tissues. Vrykozine retards it. It makes you weak, no stronger than anybody else, makes you look like the living dead, and smell that way, too. And don't let them tell you it's not addictive. They made it that way. You'll be easily controlled, and very, very visible."

"But—" Reyna stammered. "The hunger...I'm afraid."

"You want me to keep talking, or hang up? Say which. I'm calling from outside the country, and it's my dime, and my risk if you tell anyone." The man was sharp, hurried, edgy.

She took a deep breath and let it out slowly. "Yeah, go on. I'm listening." Running her tongue over her teeth, she suddenly realized that she had been absently licking two sharpish lumps that had partially broken through her gums. She turned her face away from the phone and retched, covering her mouth, and almost missed the man's next words.

"—sure, it stops the hunger, and that means you don't eat, and you're weak. Don't you see? They want you that way."

"How did you find out about me?" she whispered.

He ignored that. "Have you tasted live blood yet?"

Long silence. "I—yes. But I didn't mean—"

"Good. Then you've already broken the guidelines. You're a predator now. Look, this virus of ours is what lets us feed and then close the wounds so the feeder is OK, right? It's in our saliva. But if you decide to grab someone after you're on the drugs, you'll have a gushing fountain and a corpse real fast. Bad for you, good publicity for the anti-vampire lobby in Congress. 'Course, if they find out about you, you'll lose your job, get put under

watch, maybe they'll get a court order to hook you to an IV in a very, very strong cell."

The stumps were slightly loose; she could push them in and out of their sheaths with her tongue. "So what would you suggest I do, then?"

"Get out. Soon. Now. I'll email you an address, but only if you're sure. I mean it. You're now a member of a minority that barely has a right to exist. You'd better start acting like it."

Reyna's thoughts whirled and her belly grumbled. So soon? Shit. Go to Canada, Val said. Val...Three days by my bedside. She was crying, and I threw away her gift. "Send it," she said abruptly. "But not to me. To Valerian Sayres, here in Boston. My girlfriend."

"Lucky woman," said the voice, and hung up.

Reyna sat against the wall for a long time, running her tongue over the sheaths of her fangs, trying to get herself accustomed to them. Predator. The grey daylight had faded and she felt better, not so dragged-out. Finally, sighing, she pulled herself to her feet and went up to the bedroom. Better face Val with this tonight, while it was still fresh in her mind. Before she had a chance to get scared again.

The door was closed, but opened at a touch. Val lay on the bed, naked, hands secured behind the

small of her back. Her knees were drawn up slightly and her dark hair was carefully brushed back, exposing her throat.

The rat, in its cage, scuttled noisily on the night table.

Reyna closed the door slowly and took off her jacket. Val's dark eyes flickered open and blinked in the light. "Mistress?" she said huskily. "I fell asleep waiting for you. Are you feeling any better?" Her hips moved suggestively.

Her mistress shed her T-shirt and boots and paused, unknotting her kata pants. "Val, I'm not sure we can do this. I mean, it sounds romantic and all that, but I'm really afraid I might hurt you." She dropped her pants and sat on the bed, stroking the soft dark hair. Val moved into her touch, rubbing her face against her mistress' hand. "No, let's be honest. I'm afraid of killing you. And it would kill me if that happened."

Val sighed. "Kilogram." It was her safeword. She struggled to sit upright with her hands bound. "Love, haven't we been through this before, years ago? I've been your slave for four years and you've never even sent me to the hospital, although there were probably a million times when you could have lost it and killed me. You didn't. I trust you." She rubbed her face against Reyna's bare shoulder. "There's no one more qualified to hold someone's life in their hands than you. I can testify to that."

The collared woman's pulse seemed to thunder in Reyna's ears. "What if I can't stop?" she whispered.

"That's why I bought the rat. I figured it might take the...uh...edge off." A giggle, and Val lay back down on the bed, wiggling her hips again.

Reyna blinked and then suddenly found herself laughing. "Got it all planned, huh?"

Val kissed the stroking fingers. "Love, considering our activities of the last four years, I've probably got this virus dormant in my own system. Some day you may have to do this for me." Her teeth nibbled gently on Reyna's knuckle.

"Oh." Her breath came out of her in a whoosh. It was a full minute before she realized that she had no physical need to inhale, except to speak. And there seemed to be no more need for words. Her hand went for the rat's cage, flipped open the lid, and dived for its wriggling body. It seemed to move far slower to her than a rat ought to. Should I kill it first, she wondered, or just... Her nostrils flared, and she could just barely hear the tiny heartbeat, the pumping of the veins, the quick whoosh of breath as it fought for its life in her grip. The sharp teeth slid out of their sheaths as easily as a cock from its foreskin, and then she had a faceful of furry squirming rat as they sank into its tiny beating heart. It bit her ear, which distracted her but

didn't seem to hurt much, and she broke its neck with one squeeze and emptied its little body.

Gasping, she flung the corpse across the room and sat, breathing heavily. Her ear was starting to hurt now. "I don't want to be the one to clean it up," she croaked. "Not this time. And now I know to kill them first."

Val, still bound, got up to her knees and nuzzled her mistress. "I'll slit their throats and serve it to you warm in brandy snifters," she whispered.

Reyna smiled and kissed her forehead. "Yes," she said. "You do that. Slave."

The collared woman lowered her head. "Yes, Mistress," she whispered. "Would my mistress like to take her nourishment from me now?" She rubbed her crotch in circular motions on the bed. "Val has missed you so."

Her body was deliberately inviting, pale and vulnerable with the delicate blue tracings of veins. Val had always known how to inflame her; it was the great power of the submissive. Heat flooded upwards from Reyna's crotch, and she realized that she was wet, very wet. Mine, screamed the overpoweringly irrational urge of the predator, and she grabbed her lover and hauled her face down over her lap. Val moaned and thrust her ass upward. "Hurt me, Mistress," she gasped.

I could break her bones, Reyna realized. *I'm that strong. But I won't.* She slapped the upturned ass a dozen times, not very hard, but the red marks were coming up and Val was crying out and thrusting upward even more. Her legs were open, and the redolent scent of her cunt was almost like mist in the air. Reyna tumbled her off the edge of the bed, holding her by her dark hair so that her head wouldn't meet the ground. "Lick me, girl," she commanded, lisping around those damned fangs, thrusting her slave's face into her own crotch. Then her hand went to the wall, to the whips hanging in a fan-shaped array. A split-second decision —not the horsehair tail, not the braided whip, I know Val, she needs it hard!—yes, the broad-tailed indigo cat—and then the chosen implement slammed down on her slave's shoulders as she nuzzled her way between Reyna's nether lips to her clitoris. She whimpered, but kept her tongue flicking, circling, rubbing as another lash followed, and another.

Reyna felt as if her mouth was a second erogenous zone, aching and swollen like her cunt. Val whimpered and flinched as the cat fell on her back, getting up on her knees and thrusting her reddened ass out to take more of the blows, but her mouth never left its work. "Enough," her mistress growled. Hunger filled her to the point where she couldn't finish the whipping, or even make it to orgasm.

Hauling Val up by her hair, she lifted her off the floor with one arm and flung her onto the bed. The dark-haired woman had one second of astonishment at the ripple of strength in that move before Reyna was on her, straddling her thigh, one hand going for her cunt and the other scrabbling desperately at the hair tangled around her neck. She twisted to help the effort, baring her neck above the collar, and spread her legs as wide as possible. The first thrust was three fingers, and the second found her wet enough to jam four fingers inside her, fucking hard.

At her throat, Reyna froze. She could smell the iron-rich river in that blue vein, could hear Val's pulse like thunder in her ears. Her hand on Val's cunt, her own cunt pressed against her lover's thigh, she paused and forced herself to take five deep breaths. *To prove I can stop,* she thought to herself. *Even here, even now, yes, I can stop. I am in control Oh, gods, but it hurts, it hurts!*

Val thrust her hips up, moaning, taking in more of Reyna's hand. She arched her neck back even further, wanting, wanting..."Do it, love," She whispered. And the next thrust was five fingers below and two fangs above, and she orgasmed.

Then it was like floating, like pain and ecstasy, like drowning. Reyna climaxed, but it was almost an afterthought to the relief in her jaw as her

lover's blood slid down her throat in gulps. It was all tied together now, she realized dreamily, sex and feeding inextricably linked.

Val came again and again, three times, four, cunt contracting around Reyna's hand over and over, sweet pain in Val's throat mixed with the faint feeling of strangulation, and then she was thrust up out of the watery crimson depths like a fish thrust out of water, gasping.

Reyna had collapsed next to her, also gasping. Then she closed her eyes and stopped breathing for a minute, seeming to draw into herself. Val waited, turning her own head from side to side, trying to feel the holes in her neck. There was nothing but a faint tingling. Finally Reyna uncurled from her trance and opened her eyes, smiling at her lover. "Roll over," she said huskily, "and I'll get you out of those cuffs."

"Are, are you all right? Was it...enough?" There was both love and trepidation in Val's tone.

A chuckle from her mistress as she struggled with the cuffs. "I should be asking you that. I'm fine. Completely fine. Are you?"

Hands free, Val touched her throat. Two small indentations were fading fast. "Tired, but no more than I usually would be. Kiss me?"

Their lips touched. Reyna's fangs were still out; Val ran her tongue over and around them, playing,

tasting her own blood on them as they slid back into their sheaths. "I like them," she mumbled around the kiss.

Reyna pulled away. "Can we make it to Canada in forty-eight hours?" she asked hoarsely.

Val was silent no more than ten seconds. "Yes," she said. "Tomorrow we close out our accounts, quit our jobs, sell the car and buy a camper. We can do it."

"I love you," said Reyna. Then she didn't feel that it sounded like enough, so she said it again. "I love you."

"Love y'too. Wanna sleep." Val buried her head in Reyna's shoulder.

"I'm awake. I should stay up and pack."

"Hold me. Till I fall asleep..." her voice trailed off. Reyna pulled the blankets up to her lover's collar and snuggled in next to her. *I wonder, she thought idly, are there deer in Canada, still? And could I run fast enough....*

The Brass Ring

Gary Bowen

When I returned from the shower the evening sun was shining directly on the front of my house. Thick hazy sunbeams forced their way through the shutters of my room, and dust motes danced like a cloud of tiny pixies. The pale birch furniture glowed in the light, and the thick gold and cream rug looked like a magic carpet ready to fly. It was like crossing the threshold into another, better world.

I piled up the pillows and lay down against them, sinking down, damp ringlets of black hair sticking to my white bathrobe and clinging to my neck. The soft pillows and clean sheets felt good. I was all those things a man is when he has just awakened: a little sleepy, a little hungry, and little horny. I burrowed into the pillows, reluctant to get up and face the day.

Michael's car rumbled to a stop in front of the house, and I bestirred myself. I rolled to the edge of the bed, opened the top drawer of the nightstand, and deactivated the burglar alarm. His key scraped in the lock as he let himself in, and I turned the alarm back on once he closed the door behind him. A few moments later he called, "Rafael?"

"Upstairs!" I shouted back. I settled back against the pillows while he trotted up the stairs.

He took a jaunty step into the room, and I smiled to see him home again. He was clad in a red sleeveless muscle shirt whose large armholes emphasized the bulging roundness of his shoulder muscles, while his jeans were worn to white threads at knees and crotch. Enough skin showed through the holes that I wondered if he were wearing underwear or not. The possible lack of lingerie made my blood simmer, and I grinned up at him with keen appreciation. He was my denim Adonis, and I adored everything about him, right down to the battered brown cowboy boots.

"I saw Ponch today," he said cheerfully.

"Ponch?"

"Ponchartrain. But he's so fat, I call him 'Paunch'. Don't tell him I said that." His twinkling eyes said he meant no harm.

"George Ponchartrain?" I asked in bewilderment. "Fat?"

He leaned against the bedpost. "Well, I guess it depends on how you define 'fat'. Not so bad for an old guy."

I cringed. The George I remembered was young and burly, with muscles like a Greek hero.

"How did it go?" I tried to sound enthusiastic, but it was hard. I was distressed about George.

The sparkle in his eyes grew even brighter. "He bought one. And he took three on commission."

"Great! Which one did he buy?"

He grinned easily. "Your picture, of course. The one I just finished. His eyes bugged out of his head and he pulled out his checkbook and wrote. No argument."

George had photographed me plenty of times; I could well imagine his appreciation of Michael's painting. "I wonder what Damon thinks of it."

"He asked George if he was keeping a tart on the side. I told him not to worry, you were already taken."

"I've been called a lot of things, but that's the first time anybody ever called me a 'tart'!"

He leaned forward and kissed me. "Good to eat," he murmured.

"Glad to oblige you," I replied.

He straightened. "I cashed George's check on the way home so I have two thousand dollars burning a hole in my pocket. We're going out to eat."

At that moment I would have agreed to any-
thing, but the thought of dining (and throwing up)
in public gave me pause. I sat on the edge of the
bed, looking up at him. "Wouldn't you rather have
dinner at home? We could have a lovely candlelight
dinner, a little wine, a little music, just the two of
us..."

"You're very tempting, but I know if I stay home
alone with you, I'll never get my dinner. You have
an irresistible way of distracting me. You have to
keep my strength up if you want me to satisfy your
appetites."

My eyes dropped to his silver belt buckle. "I'd be
happy to keep you up."

He shook his finger at me. "That's exactly what
I'm talking about! But tonight I'm holding out for
steak and champagne before you get yours."

Barbarian, to mix white wine with red meat. But
if that was what he wanted, I was willing to go
along. "All right. Toss me my suit."

"I'm going as is, and I forbid you to wear a coat
or tie." He tried to give me a stern look, but his eyes
twinkled and he grinned when I laughed.

"Your wish is my command, O Mighty Sultan,"
I said reclining upon the bed and pretending to
smoke a hookah. "Your slave will wear whatever
you desire." With emphasis on 'desire'.

"Do I get three wishes, like Aladdin?"

I grinned. "Of course. And until the three wishes are granted, you are my lord and master." Lying on my side hampered me a bit, but I made an flamboyant bow by touching my fingertips to forehead and chest, then flourishing them in a circle. That might not have been exactly how the Arabs did it, but it was good enough for our little game.

"My first wish is that you go a whole week without wearing black."

I laughed. "Done. And your other wishes?" I asked lewdly.

"I'll let you know as soon as I decide on them."

I could imagine all manner of things worth wishing a lover to do, and the erotic images made me fidget. For example, mutual kissing starting at the toes and working in to the middle. Unfortunately, I had neglected to stipulate that he had to rub my lamp to get his wishes.

Michael was rifling through my closet in search of something not-black when he suddenly seized on a sliver of yellow at the end of the rod, mostly obscured by the other clothes.

"Not that," I said in alarm, sitting up straight.

His hand clamped onto the hanger and pulled.

"No," I said, "I won't wear that in public."

He held the dress against himself. "And you told me you weren't a queen."

It was a yellow frock, covered with coral cabbage roses and olive green leaves, with short sleeves, a wide white collar, and full skirt. It buttoned up the front with yellow cloth buttons. I had it so that when hunting was lean in the gay clubs, I could take female form and hunt the straight clubs. The dress was not a fetish; it was a hunter's camouflage. But I could not tell him that.

"I'm not a queen," I protested lamely, not wanting to explain my promiscuous feeding habits. We could burn that bridge when we came to it.

He was grinning as he peeled the dress off the hanger and tossed it at me. "Get dressed. I want you to wear it when we go out. That's my second wish."

With my eyes I pleaded for mercy.

"Go on, I want to see you in it."

I let my robe fall, exposing my mostly hairless pale body, then blushing furiously, stepped into the dress. It was tight across the chest as I buttoned it up. I tugged it uneasily, trying to find a more comfortable position.

He pulled a second hanger from the closet, unclipped the white lace garter belt and sheer silk stockings, then passed them to me. My face was burning with fiery color as I pulled up the skirt and fastened the garterbelt around my waist. Then I sat on the side of the bed and pulled up one sheer stocking and hooked it to the garter belt, then the other.

When I was in female form, getting 'dressed' did not embarrass me, but with him leering down at me, it was definitely kinky. It dawned on me then that he liked this particular form of deviancy. I glanced coyly up at him and said, "O Mighty Sultan, do you wish your slave to go barefoot, or will you provide her with shoes?"

He tore his eyes away from my legs, and knelt to rummage among the shoe boxes in the bottom of the closet. After opening and closing several, he found the black leather pumps with the four inch heels and ankle straps. He knelt before me, and ignoring his own prohibition on black, slipped the shoe on my left foot buckling the strap with trembling fingers. I offered him the other foot, and he kissed it softly before slipping it into the shoe. He fastened the buckle, then slid his hand around my ankle and up my sleek calf to the hem of the dress.

"It's a muscular leg," he said with a low voice. "But with all the women who work out, it's perfectly believable." The baritone tremor of his voice sent shivers up my spine.

I crossed my knees, letting the skirt ride up to my stocking tops, but still preserving my modesty. "You like me like this?"

He nodded. "You look like a beautiful lady, but underneath you're all man. It's amazing; it's like you're twins, one male, and one female." He grinned crookedly. "Twins are a fantasy of mine."

I could readily imagine him in the middle of a three way with a man and a woman, and I wondered if my shapechanging ability could manage to produce two of me at once to oblige him. "I'm a shapechanger," I said huskily. "I could be a woman if you want."

His eyes popped. "You could?"

I nodded. "Want to see?"

He nodded mutely.

I closed my eyes and concentrated, my body softening and reforming, the dress still in place, but fitting properly now. I unbuttoned the four cloth buttons and showed him two perfect breasts.

"Those are great tits," he said in honest admiration.

I uncrossed my legs, and spreading my knees wide, lifted my skirt to my waist. His eyes dropped to my black haired pussy, then bugged out of his head.

"Is it real?" he asked. "I mean, if I touch, will it feel like it looks?"

"Yes."

He put his hand between my legs, laying his palm over the mound of soft flesh and hair, leaning his body between my knees, face thrust close to mine, lips seeking mine. The pressure of his hand against my pussy sent startling waves of heat through my body, and I lifted my mouth to his. He kissed me strongly.

"I've never done it as a woman," I murmured against his lips.

"I'm good with virgins," he replied.

His mouth ravished my neck, soft lips caressing my skin while I lifted my chin to allow him full access to my vulnerable throat. He nipped it, and I let out a sharp gasp of air. His tongue trailed down my neck, then paused as he nestled his lips against the cleft in my collarbone, kissing it devotedly, sucking it, and running his tongue along the bone.

He pulled the front of my dress open to reveal a narrow triangle of flesh which his lips followed, walking softly down the cleavage between my breasts while my nipples strained against the fabric, eager for his touch. He peeled the fabric back, exposing my right breast, his hand cupping it gently, then firmly as his mouth came down upon it. I arched, forcing more of my flesh into his mouth, a line of fire burning through my body straight to my cunt. Fluids began to ooze and drip between my legs.

"Oh, stop!" I whispered, overcome by the sensations that were at once familiar and alien. I felt as if reality had taken a half twist to the left, so that everything looked the same, but nothing fit.

Michael lifted his head and looked at me, then pulled himself up so that he could embrace my shoulders and kiss me. His hard groin pushed against my crotch, and rockets of desire shot

through me, obliterating minor technical differences between who I was, and who I had been. I wrapped my legs tight around his body, thrusting up against him, groaning in passion, wanting the union of our bodies, totally engrossed in the unfamiliar (yet similar) female sensations.

Michael slid down my body again, using his strength to force my legs and arms to loosen. He slid lower and lower until suddenly he was kissing my nether parts. His lips planted soft, firm kisses on the hairy mound of flesh at the bottom of my belly, and I collapsed onto the bed limp with astonishment, feeling like I was drowning in wet velvet. I could smell myself, the ripe, voluptuous female smell like fruit that would rupture on the vine if it were not picked.

I moaned long and low, my hips writhing, when suddenly his tongue flicked a small bump of intense pleasure. He nursed it with his mouth, electricity shooting down my legs, making my feet tingle, limbs twitching helplessly as he alternately sucked and licked it. My hands clawed the bedspread, and I groaned and tried to drag myself away from him, but he held me fast.

At last he took pity on me, and releasing my clitoris he slid his tongue up and down my dripping wet slit. He sucked on one labia, then the other, then held me open with his fingers while he licked

me from hole to point. I buried my fingers in his hair, pulling unmercifully at his head. He deposited kisses all over the softly swollen flesh of my sex while I jerked and twisted.

"Fuck me!" I cried.

He caught my clit in his mouth again, pinning me to the mattress, while one hand slid down my slit, fingers gently probing for my opening. My back arched and I trembled, because Michael was taking me where I had never been before, and I was desperately afraid I was going to like it.

Two fingers sank into the soft, wet, warm opening of my body, and I squirmed, pushing myself onto his hand while my brain ran screaming in the opposite direction.

"No!"

He lifted his face and watched my reactions while his fingers found something inside me and tweaked it. A bolt of white heat shot through my body.

"Do you really want me to stop?" he asked mischievously. "I will, if that's what you want."

For answer I groaned wildly, hands beating the coverlet, then spread my legs wider. "Take me!" I cried, too far gone with lust to make any other answer.

He squeezed me gently with his thumb on my clit and his fingers inside my cunt, then rubbed

them simultaneously. The internal pressure made me feel like I was going to pee, and I clenched my muscles, trying hard not to wet myself with excitement. But in spite of my efforts, pearly white fluids oozed around his hand, and the aroma of bitch in heat wafted through the air. The coverlet under my ass was getting very wet, and I squirmed, desperately fucking his hand, yearning for the intimate congress of his lust and mine.

Michael removed his dripping hand, then sat up and unzipped his pants. The prick which had given my male self such pleasure now seemed huge and impossible when it was pointed at my newly deflowered flesh.

I scrambled to a sitting position. "Oh no you don't! Not with that!" I cried in sudden panic. This fantasy was going much further than I was prepared to handle.

He caught me in his arms and bore me down, his hard flesh poking against my sopping wet hair. "I want to," he whispered hotly in my ear, "It's my third wish."

I wanted to change shape and run far away. But at the same time, I would curse myself for a coward if I quit now.

"Please?" he asked.

"Do I have a choice?"

"Yes, of course." He tried not to look disappointed as he sat up. Putting his hand on his cock

he began to stroke himself. I watched him enviously
because it was a gorgeous cock, and I did want it,
even if it scared me.

"I didn't say no," I told him.

He leaned forward so that his breath was brush-
ing my lips. "Will you let me make love to you?"

"Yes," I whispered. The panicked rats started to
run wild through my brain, but I ignored them
because I wanted to please him.

He stripped off his shirt and pushed his pants
further down his legs, then lay down between my
legs.

"Be gentle. I've never done this before," I
begged.

He nodded, then sheathed himself in my body.
I screamed.

It was a perfect fit, my hot, wet flesh taking him
easily as he buried himself to the hilt. He held still,
waiting for me to calm down, but I did not. The
sensations were indescribable, and I kicked vio-
lently, then locked my legs around his waist and
thrust my hips against him, nails biting into his
shoulders, wild animal noises coming from my
throat. I wanted to fuck him senseless, wanted to
engulf the entirety of his hard body with my soft
wetness, wanted to suffocate him with my thighs, to
reduce him to nothing but the hot seeds of sex that
grew inside me, swelling my belly from the inside,
the ultimate invasion of my flesh.

He began to pump me, his hardness sliding easily through my slippery flesh, his eyes closed, his expression blissful. His arms wrapped under my back and neck, supporting my head so that he could kiss my face. He was a well-practiced and skillful lover, pacing himself and not letting the primal thrashing of my body overwhelm his consideration for my pleasure and my comfort. I hated him for it. I wanted to come, I wanted him to come, to crash into the mind-stopping double climax—no, I did not want him to come! How stupid of me, I was female, and we were not using a condom, I could get pregnant!

I don't want to be a woman!

His body heated up, the expression on his face becoming more intense. Perspiration gleamed on his brow, and his strokes became harder, deeper, more demanding. My back arched, my heels drummed on his ass, and my fingers clawed his back as I fought him, trying to tear him away from me with my hands while my legs locked him tight against my belly. A great pressure built in my body, and I shrieked, having no other way to release the intensity.

Suddenly he slammed me with short sudden strokes, driving the sensations of my body to a higher, intolerable level. A floodtide of sensation rushed through me, drowning me in a maelstrom of velvety wet softness. Suddenly my body went rigid

and my breath stopped, my pelvis jerked and shuddered, then my back went limp, and I sprawled in sudden relief, stars circling inside my closed eyelids. Slowly I realized that this was orgasm, female style.

Michael lay languidly against me and I wondered if he had come. He was so relaxed he must have; I had been so busy with my own climax I had missed his.

"Don't you ever do that to me again," I hissed at him as soon as I caught my breath.

"Did I hurt you?" he asked in surprise.

"No."

"What did I do wrong?"

"I'm a man, and you fucked me like a woman!"

"Well, you are a woman, at least for the moment," he replied in bewilderment. "What was I supposed to do?"

I pressed my hands to my head as if to crush my skull. "You like me better this way, don't you?"

"I like you every way I can get you. Yes, this was a lot of fun, but you're also a lot of fun when you're male."

"Which do you prefer?"

"Both."

I glared at him.

"Really, Rafael. I do. I like you both ways, and I like doing it both ways, and I would hate to be stuck with only one, whichever one it was."

"Life would be easier if I was female."

He laughed then. "Who cares? I would rather have an interesting life than an easy one."

"You don't understand how I'm feeling!"

He sobered. "I've fucked you before. Is it really so different?"

"Yes!"

He cocked his head curiously at me. "Wanna tell me?"

"All my life I've been a kinky gay man. It affects everything I do, everyone I meet, everything I feel. That's a very intense and very different kind of life. Now suddenly, here I am, flat on my back, female, vanilla, and normal! It isn't fair! For years I've been persecuted because of who I am and who I love; now suddenly I'm socially acceptable, just because my plumbing has been rearranged. It's the rankest kind of sexism!"

"I see your point, but it doesn't matter to me. I think you're wonderful, and anybody who doesn't agree with me is an idiot."

"Thank you very much. Now get off of me; I want my body back and you're in the way."

He obligingly lifted himself off me, and I sat up, yanked the dress off, shed the garterbelt, shoes, and stockings. Then I squeezed my eyes shut, and gratefully reclaimed my natural masculine form.

Michael pulled up his pants. "Still want to go out with me?"

"Do I have to wear a dress?"

He grinned wickedly. "Are you gonna welsh on my second wish?"

"I never welsh on a deal," I said hotly, then squirmed. "Of course, if you've changed your mind—"

"I haven't."

"You're not going to let me off easy, are you?"

"Do you want me to?"

This was discipline of a different kind, more subtle and more psychological than the discipline James had administered with whips and chains. That was pure physical sensation, like skydiving or other daredevil sports. Michael was playing with my head, illuminating the dark places in my mind where I had never cared to look too closely before. Did I have the courage to play his version of the game? And yet, what courage did it require to play a game I could quit any time? Michael would never force me, never threaten me, never hurt me. Michael was safe.

I smiled, and pulled the dress over my head. "All right, but if anyone gets too close, you have to deck him for me."

He grinned easily. "I have a brown belt in judo. I'd be happy to protect your virtue."

"Hmph. If I had any virtue you wouldn't have talked me into this." I was stronger, faster, meaner,

and tougher than him; if there was any fighting to be done I was the one to do it. Yet even though logic told me it was silly, his gallantry made me feel safe. It was nice to have someone looking out for me instead of always having to look out for myself.

He rose and offered me his hand. "Shall we go to dinner?"

I accepted his hand and rose gracefully. "With pleasure."

I stepped out on the front porch while Michael locked the door behind us. The warm breeze blew my skirt around my legs, and the fabric fluttering across my groin tickled and teased. I had often gone nude under my pants, but a skirt without underwear felt distinctly lewd, dangerous, and most of all, accessible.

We crossed the avenue without incident. Nobody was looking twice at me; the passing motorists and occasional pedestrians were paying no attention to us. There were no dropped jaws, no crude leers, and no shouted insults. I was passing as a woman. As long as I could keep it up, we could enjoy the same privilege straight couples enjoyed: to walk hand in hand without fear of ridicule or assault.

I hooked my hand in the crook of Michael's arm and smiled at him. He grinned back at me, white

teeth gleaming while his other hand came to rest possessively upon mine. Like Siamese twins joined at the elbow we cut through High Hill Park towards the respectable, touristy heart of the city.

We came onto the red brick quay between the pentagonal tower of the World Trade Center and the green glass of the Pratt Street Shopping Pavilion. The mingled smells of popcorn and dead fish wafted through the air, giving a unique scent to the breeze, which apparently did not bother anybody but me. Men and women in business suits lingered after leaving their offices, mixing in with the crowd dressed in shorts and sports shirts. A mime walked along an invisible wall, and a clown was selling helium balloons. Moored around the edges of the basin was a collection of ships: skipjacks, Baltimore clippers, a lightship, a submarine, water taxis, paddleboats, and many kinds of pleasure boats all of which scudded blithely beneath the cannon of a great black frigate.

Faintly the sound of a steam calliope drifted across the water.

"Look! A merry-go-round!" Michael pointed towards the glimmer of lights further along the shore.

"An old one too. It's missing some animals."

"If we hurry, we can catch it!" His long strides thoughtlessly ate up the distance while I tottered desperately on high heels trying to keep up with him.

"Don't you think we're a little old for carousels?" I protested breathlessly as we arrived at the ticket booth.

He grinned and said, "Two please." He accepted the chits and handed one to me. "Maybe you are, but I'm not. Besides, I guarantee a ride on a merry-go-round will take ten years off your age!"

I balked. "I don't want to take ten years off my age."

He stopped short of the white metal gate, puzzling over the problem for a moment, then his face brightened. "You said I was your lord and master until the three wishes were granted."

"You've used up your three wishes, Aladdin," I countered.

"Ah, but it will be a week until the first one is granted, and you said that until the wishes were granted I was your lord and master."

My mouth quirked in a suppressed smile. "I said that, didn't I."

"You did indeed."

I smiled at him, bad humor evaporating before his twinkling hazel eyes.

"Very well, what is your command, O Mighty Sultan?"

"To ride the merry-go-round. And more than that, to have a good time while you're doing it."

I curtsied grandly. "It shall be as you command, O Puissant Prince. The sun shall halt in the firma-

ment, and the stars shall shine during the day. Ten thousand nubile maidens shall feed you pomegranates and honey while forty thousand naked youths rub your flesh with oil and a hundred thousand slaves strew your path with willow leaves."

"One is enough for me. I wouldn't know what to do with a hundred thousand slaves."

"Your Majesty's faith in this humble servant will not prove unfounded." I swished through the gate, glancing coyly over my shoulder at him.

"I'm sure you will live up to my expectations," he murmured in my ear, then seized me by the waist and lifted me lightly to the deck of the machine. He jumped up beside me as quietly as a cat in spite of his boots. My heart did flip flops but he was oblivious to my emotional vertigo.

"Look! Pigs!" he exclaimed starting towards them.

"It's undignified for the Great Sultan to ride a pig," I objected, taking refuge in the game. I stopped beside a prancing white horse.

"Horses are boring. Every merry-go-round has them. The pigs are cute."

I glanced around for an alternative. Grandparents were picking up small children and seating them on zebras and lions; our choice of animals was dwindling. "How about the roosters?"

He bit back words, then succumbed to temptation. With a wicked grin he retorted, "I really don't think gay men should ride cocks in public."

My jaw dropped. Then I tried to answer him, but could not. I resorted to non-verbal communication: I hit him.

"Ow!" He darted to the other side of the pony. "That smarted!" He rubbed his arm.

Looking around quickly to make sure nobody was near enough to hear me, I retaliated, "If you're going to think such dirty thoughts, then let me remind you that the Latin word for 'pig' is 'cunt'! I don't think you ought to be riding pigs in public either!"

"Touché!" He laughed delightedly. "Well, how about the goats?"

"Horny as a goat, are you?"

He grinned. "You win. We'll ride the horses."

"Mmm. Studs. The perfect choice."

He hit me back. "That's enough!"

"You started it!"

"Okay, truce?" He held out his hand.

I shook it. "Truce," I agreed.

We self-consciously mounted two white ponies, our puns having made us all too aware of the ribald interpretations of the act. I settled myself side saddle, legs twined together and my skirt tucked around them to preserve my modesty. The wooden animal was frustratingly hard against sensitive portions of my anatomy.

"And I thought merry-go-rounds were such wholesome family entertainment," he lamented.

"Blame it on the Victorians," I said. "They developed the carousel as we know it, and they sublimated sex into everything."

The carousel cranked up with a jerk and a rattle, cutting off any answer he might have made. A worn recording of a steam calliope began to play John Philip Sousa's Washington Post March at a deafening volume.

"There are times when being a musician is a definite drawback," I shouted over the noise.

"It's fun!" he yelled back.

The carousel picked up speed, the brass poles lifting our horses in a relaxing rocking motion, like waves rocking a boat. Michael grinned at me. His knees stuck out akimbo because his legs were too long, but he had put his feet in the stirrups anyhow.

"I haven't done this since I was a kid!" he called to me. "I forgot how much fun it was!"

In a flash of sudden nostalgia I remembered what it was like to be young. "When we were kids, they had a machine with an arm that dispensed metal rings. As you went past it you tried to grab the rings. All of them were grey, except for one, which was brass. The girls would always beg the boys to grab the rings for them because they were in skirts and had to sit sidesaddle. But sometimes a girl would try for the rings too, and then she'd topple off headfirst, her skirts flying."

"What happened if you got the brass ring?"

"You got a free ride on the carousel. But some girl would beg it from you, and you'd have to buy yourself another ticket to ride along with her. And the boys would compete to see who could get the brass ring the most times. Oh yes, we spent a lot of money for the privilege of going around in circles!"

"If I caught the brass ring, I'd give it to you. You wouldn't even have to ask!"

"I was going to give it to you!"

He grinned wickedly. "Considering what you're not wearing, I'd love to see you try—and fail!"

I blushed badly. He sat grinning at me as we went round and round, and I sat smiling back at him, the two of us gazing at each other in mutual adoration. I was a cynic, I knew we were acting like a couple of pudding-headed teenagers, but oh! It had been such a long time since anybody had ignored my dignity and made me enjoy myself!

I was sorry when the carousel began to turn slower and more slowly. At last, with a clanking of machinery, it came to a stop. Michael swung off his steed, cowboy boots thumping on the deck. He held up his arms to me, and I leaned into them. He gathered me to his chest and kissed me tenderly, slowly, and thoroughly, my toes trying vainly to find the floor. Then I forgot about the floor, for I was floating on cloud nine, kissing my boyfriend in public for the first time.

"Look Grandma, that man is kissing that woman!"

"Yes, dear. They're in love. Don't bother them."

Michael lowered me to the floor, our lips parting reluctantly. His pupils were huge, completely obscuring the hazel irises, their darkness sucking me in, my legs unsteady beneath me. I closed my eyes, feeling like the two of us were at the center of a hurricane; the world whirling past, but leaving us untouched at the center.

The female dress had given me an evening of freedom I had never known and could not bear to give up. How could I go back to censoring myself, to pretending that I was indifferent to the one I loved, to acting straight to avoid offending people, to making up excuses to appease my family, to letting other people control my life?

"Michael, I can't go back in the closet. You've brought me out of it, and I like it. But I'm worried too, because I don't want anything unpleasant to happen to you because of me."

He clasped me gently in his arms. "Nothing is going to happen. And if it does, it won't be because of you, but because of some redneck who butted in where he didn't belong."

"But—"

He put his finger against my lips. "No buts. Other people don't arrange their lives to suit you,

and you don't have to change your life to please
them. Just be yourself." He grinned. "Whichever
self you feel like being at the moment."

I laughed. "Whatever you say."

"No. It's your life, whatever you say."

Emotion shot through me, emotion I had not
dared to feel for the thirty-five years of my unlife.
In less than a week Michael had breached my armor
and found a soul I thought I had lost.

"I love you," I whispered.

"I love you too," he replied.

Our kiss went on forever.

Loved to Death

Dave Smeds

Tom leaned back against the pillows, chewing the complimentary mints he'd found on the bed. The flavor of the candy blended pleasingly with the traces of alcohol lingering on his tongue. One more thing gone right.

The woman ran her eyes over his naked body with an appraising intensity. To judge by her hungry smile, he must have met her standards. Draping her gown across the back of a chair, she began languorously removing her lingerie.

Tom gasped as the bra dropped away. Once he'd seen the padded cups, he'd expected to be disappointed. But this was better than anticipated. Her breasts, still ample though not as full as they had seemed while clothed, hung as if gravity didn't apply to them, as symmetrical as a model's, capped with sharply defined, cloud-pink nipples and areolae.

Already nearly hard, his cock stiffened to hammer-handle rigidity as she glided out of her slip

and panties and casually tossed the articles over her
shoulder. Tall, slim, not a mole or chicken pox scar
out of place—Tom couldn't believe he'd found such
a classy, and classic, dame just by cruising a hotel
bar.

It puzzled him that she would bother with the
padding. Or with the wig. The hair looked good,
but he suspected her natural curls would win in a
comparison. Didn't she realize what a prize she
was?

"I'm going to give you the fuck of your life," she
said. The confidence in her tone certainly didn't fit
the picture of someone with a low self-image.

She climbed on hands and knees up the length
of the bed, stalking along his body like a lioness
claiming her meat. She took firm hold of the head-
board and lowered her crotch to within two inches
of his mouth.

Her fresh, delicate aroma settled on him, sum-
moning his tongue. He parted her lips by plowing
gently from perineum to clit. She sighed as he com-
pleted a circuit around the outside of her labia,
working her over with soft strokes until every part
of her cunt gleamed with slickness.

"Yes," she murmured.

Tom opened his mouth wide, pressed his lips
just inside the halo of her pubic hair, and drew her
labia inside, sucking and rolling her flesh back and

forth with his tongue. She squirmed with delight, tensing and rocking so much that she accidentally lifted herself out of his mouth.

"Oh, oh," she said urgently, and lowered herself down. "Again."

Tom's cock throbbed. His hips lifted off the mattress and came down again, humping the air. It was a turn-on to see how hot he was making her. It would make the moment when she finally touched him all the better.

He locked his mouth in place and stroked across her clit with the flat of his tongue with slow, broad, clockwise strokes. She arched up, breathing in short, barely audible gasps.

Suddenly her thighs shuddered. Her breath exploded from her in deep, heaving gusts.

Damn, he thought, what a great comer. She put every single one of his previous lovers to shame. He kept licking, making sure not to cut her off early.

She puffed less intensely, in quick, shallow bursts. Tom kept working her, just to be sure.

Good thing. As his hands caressed her butt and the backs of her thighs, he felt the tension rebuild.

She came, even more thunderously than the first time. Tom grinned inwardly and kept up the rhythm.

She came again. And a fourth time, barely pausing in between. Full, shattering climaxes, the kind that knocked most women down for the count.

But she seemed ready for more. This was getting ridiculous, Tom thought. His cock was seeping, begging for attention. He pulled his mouth away.

"My turn," he said.

She smiled wickedly, but to his relief, she immediately did what he was hoping she would. She slid down his body, running sweat-slick boobs along his chest and abdomen, and scooped his hard-on into her mouth.

Tom moaned gratefully. Damn. She was good. She kept one hand against her lips, extending the sensation beyond what her mouth could do alone. She took him all the way in, right to the root, without the slightest hint of gagging. In, out, coordinating with his throbs.

She never *sucked*. Tom's girlfriend back home always did that, and the vigorous suction always numbed him, taking a lot of the pleasure away. But this woman did it just the way he liked, keeping constant but soft pressure on every side of his cock, never clenching, letting his shaft tunnel into her like a piston in a brand-new, well-oiled cylinder.

She quivered. Though she never stopped milking him, never lost the rhythm, Tom was certain she was coming again. Jesus! Just from sucking him?

She ground her slick pussy against his knee and did it again. He could feel the convulsing of her pelvis through the bones of his leg.

Tom couldn't believe this was happening. This wasn't a real woman. This was some kind of dream chick. He was afraid he might wake up.

And if she were real, how the hell could he keep up with her? He could feel his load—thick, heavy, and massive—building up in his tubes. He was going to gush like he hadn't done since high school. Hell—like never before. Like everything he had in him was going to blast out.

She really was giving him the fuck of his life.

His balls rose up tight against the base of his prick, brushing against the palm of her wet hand. She suddenly quit sucking. She sighed deeply, straddled him, and lowered her cunt around his glistening handle.

She pumped him vigorously, pelvic bone riding on his, and his load gathered like a torpedo settling into its berth. To his awe, she shuddered again, the most intense orgasm yet. She laughed, tears popping, and then she looked at him.

His come surged. Their glances locked as he exploded. He pumped three tremendous wads into her, then a fourth, a fifth, a sixth, until he was sure white rivers would flow out of her cunt and down over his balls.

More than ever, it felt like something more than just semen was pouring out of him. The pupils of

her eyes seemed to grow larger and larger and
larger, until a huge field of glittering black covered
him.

He surged up into that blackness and was gone.

Phil, night bartender at the Sheraton lounge,
strolled nervously down the corridor beside the
hotel security officer who'd come to fetch him.

They knocked at the door to Room 511. A lean,
clean-cut man in a business suit issued them curtly
inside.

Half a dozen similar types filled the room, writ-
ing notes, taking pictures, talking on the phone. A
tall, lanky man in a trenchcoat was gazing at a mo-
tionless, sheet-draped figure on the bed. He turned
and held out his hand.

"Alexis Ward, FBI," he said, shaking Phil's hand
with a no-nonsense grip. "Glad you could come."

Ward turned back to the bed and gripped the
edge of the sheet. He paused, checking Phil's ex-
pression. Phil knew from the chill on his bald head
how pale he must look.

"It's not that bad. No blood. You'd almost think
he was still alive."

Phil swallowed. The walls of his throat clung to-
gether as if he'd tried to eat a handful of lint. "Go
ahead," he said, screwing up his courage.

As soon as Ward had pulled down the sheet, hair rose on the nape of the bartender's neck. The body lay arched upward in a pose of erotic intensity, ecstatic grin frozen on its lips.

"This the man you saw last night?"

"Yeah," Phil replied.

"You're sure?"

"Yeah. He had a gin and tonic." The bartender, though worried he might throw up right on the detective's shoes, stared unblinkingly at the body. "He looks so happy."

"Like he was fucked to death?" Ward suggested.

Phil let loose a sudden, alarmed bark of laughter, and instantly reddened, realizing the seriousness of the circumstances. "Yeah. Now that you mention it. What a way to go..."

"This is the ninth case like this I've seen in the past five years," Ward said. "Dreamy smile, not a mark on him. I'm sure there've been others, but those probably got chalked up to heart attacks."

"No shit?"

"They've happened all across the country. They're called the Love Attacks."

"I've heard about them."

Ward flipped the sheet up and stored his hands in his pockets. "Now you know how important this is. I'm told you saw this man leave the bar with a woman last night."

"Yes. I did."

"Did you get a good look at her?"

"Sort of. Bar's pretty dim. She was white, not too tall, dark hair. She had a Kahlua."

"Anything out of the ordinary about her?"

"Well, yeah. There was. I can't explain it—she was just different. Hard to say why, except..."

"Go on."

"When she reached for her drink, I could've sworn that her forefinger was the same length as her middle finger. But I never got another look."

Ward shrugged. "Probably just the way she held the glass." He gestured at a chair. "Thanks. If you'll wait here a sec, I'll schedule a visit for you with our composite artist."

"Sure. Glad to help," Phil said, relieved to be able to leave the death scene. "Say, Detective Ward. Am I in any danger?"

"No," the man answered firmly. "She never strikes in the same city twice."

The new stud fucked Marta like an athlete. She looped her ankles behind his neck and met him thrust for thrust. Her cunt ached delightedly, barely able to contain his thick probe. She came for the seventh time.

Sweat beaded his forehead. As her orgasm peaked and another began to sprout, she knew he

couldn't hold off any longer. She captured his glance and held it as he erupted. Intense joy flooded his face as he drenched her snatch, replaced at the last instant by a mild pucker of surprise. Then out "he" came, every last bit of his vitality, funneled into her.

Marta cried out, fulfillment spreading to fingertips, nipples, scalp, and heels. Like a junkie getting a fix, she sagged against the sheet and let the wave break carry her away.

Her lover's body, sapped of both semen and life essence, collapsed across her, though her cunt remained rigidly impaled.

Marta sighed. Already her sense of satisfaction, so incredibly deep a moment earlier, fumed away like steam from a tea cup.

She groaned and rolled over, laboriously hefting her ex-lover onto his back, and peeled herself off his cock. Damn. He'd been a solid catch—healthy, young, enthusiastic, and even skilled. He'd given the kind of performance that would make most women cream just to remember.

For her, it had momentarily salved an itch, lasting scarcely longer than the spark she'd burned out of the one at the Sheraton—was it Tim or Tom?— only a week before.

She'd taken everything they could offer, and it hadn't been enough.

She cleaned herself up and threw on her clothes. The sooner she left, the better. She glanced moodily at the corpse. How many had she left like that?

Marta dreamed of a day when she wouldn't have to murder anyone again. Would that be when she was caught and sent to prison, or when she was too old to maintain the urge?

She doubted it would be the latter. The desire ruled her now. One week. In times past she'd controlled herself for many weeks, sometimes six months. But she'd forgotten how she ever managed to bear it. At this rate, she was sure to be caught.

As she reached for the door handle, she took one last look at the bed. The dead man's smile chipped a flake off the marble block of her guilt. Nothing that sent a man to his grave with an expression like that could be entirely unwelcome.

She didn't *want* to kill. All she wanted was what any normal human woman wanted—someone to love her and fuck her as much as she needed to be loved and fucked. A male version of herself. Barring that improbability, she would take what she could get, as seldom as her willpower allowed.

At an airport rest room, she stripped off her make-up, removed the padded bra, and tucked her wig into her purse. An hour later she walked up to the boarding gate bearing little resemblance to the hotel barfly she'd posed as.

She canted her index fingers so that their extraordinary length didn't seem obvious—second nature to her while on these excursions. The newspaper accounts of the Love Attacks had never described a murderess with such an distinctive physical attribute, and she meant to keep it that way.

The airline attendant checked her boarding pass. The name it contained was not Marta's real one, but as usual, no I.D. was requested. She had false documents just in case. As she passed through onto the jet that would take her back to her apartment, nine hundred miles away, she wondered if she had covered her tracks well enough, and how long she would stay lucky.

Two weeks later, a knock resounded sharply on her front door. Judging by the time of day, she thought it might be a parcel delivery of the exercise equipment she'd ordered, but with inbred caution, she kept the chain attached as she opened the door.

"Marta Kendrick?" asked a tall, lanky man in a trenchcoat. She knew she'd never seen him before, but something about him seemed familiar. "I'm Alexis Ward, FBI."

She gulped and shut the door. What now? She looked toward the sliding glass door leading to her patio. She lived on the second floor, but in her shape it was an easy jump.

"We've got the place surrounded," Ward called through the door panels.

Marta's head filled with images of disguises, false trails, avoidance of hotel personnel, and all the other measures she'd taken over the previous five years to feed her hunger. The tactics had worked only because she had a mundane existence to return to and hide within. If her true identity had been discovered, the game was over.

She relaxed as if she'd just shed barbells from her shoulders, and actually laughed. All day she'd laid about the place in a bathrobe, masturbating every fifteen minutes, knowing that she'd have to take another plane trip that weekend, and would come back with one more grinning cadaver in her memory's hoard.

She tied her robe more modestly about her waist, slid the safety chain out of its slot, and swung the door wide. "How...do you do?" she asked, stepping aside so that Ward could enter.

He strode forward, turned, and faced her.

"I've been looking for you for five years," he said.

"You could say I've been waiting for you," she replied, sighing. Then, cocking her eyebrow, she glanced into the hall.

"Where are the rest of your people?" she inquired.

"I lied. I'm alone."

"But..." The furrow in her forehead grew so deep it felt like a canyon. She'd never heard of an FBI operative confronting a suspected murderess without plenty of back-up.

"The agency doesn't know I'm here. In fact, there's a lot about your case I never put in the file."

She'd so thoroughly conceded defeat, she had to struggle to realize that maybe there'd been no reason to give up.

"If you're not here to arrest me, why are you here?"

"Arresting you would be one way to retire the Love Attacker, but I didn't get myself assigned to your case to let that happen." He lifted his hands out of his pockets. "Like I said, I've been looking for you for five years. I've looked for a woman like you for a lot longer than that."

Her eyes widened. "Your hands," she whispered. His forefingers extended to the same length as his middle fingers. She knew now why he'd seemed familiar. She'd recognized him the way a pair of lions recognize their kinship amidst a serengeti full of antelope. A smile ignited on her face; she fanned it to a roaring grin.

No more guilt, no more victims, just a man who could match her stroke for stroke. Her bathrobe suddenly seemed like far too much clothing.

"Wanna fuck?" he asked.
"For about five days," she answered.
And they did.

Contributors

Tristan Alexander, artist
lives in Baltimore with his husband Don and three cats. His artwork has been featured at sf conventions and in such publications as *Prisoners of the Night* for which he has gained a reputation for stunning male nudes, especially vampyres, many of which can be found in his new book: *Manmagic: The Fantasy Male Figures of Tristan Alexander.* Commissions, correspondence, & comments can be sent to Night Mist Productions, c/o Tristan Alexander, 38 Kettle Court, Baltimore, MD 21244.

Gary Bowen
is a left-handed, gay writer of Welsh-Apache descent originally from Waco, Texas (no Koresh jokes please). He's too busy writing to hunt for a real job, so he figures this must mean he's a professional writer. He is a regular contributor to *Bad Boy* and *BiCurious* magazines, and has vampiric fiction in *Dead of Night Magazine, Into the Darkness, Heliocentric Net* and *Daughters of Darkness 2.* His gay erotic sf can be found in several anthologies, *Bizarre Dreams* and *Meltdown!* (Masquerade Books), *Bizarre Sex and Other Crimes of Passion Vol II,* (Tal

Publications), as well as his first chapbook of gay erotic sf with Circlet Press entitled *Queer Destinies*. This story was originally a part of his novel *Diary of a Vampire*, but in the final form of the novel the latter portion of the story does not appear. The novel is forthcoming in 1995 from Masquerade Books.

Renee M. Charles

lives in a houseful of cats, has a B.S. in English and also teaches writing. She has been published in over 45 genre magazines and anthologies (including *Weird Tales, Twilight Zone, 2AM* and others) with over 100 stories poems and articles published overall. Some of her major influences include Ray Bradbury, Theodore Sturgeon, Fredric Brown and Dean Koontz.

Amelia G

is a writer whose work has appeared in markets ranging from *Chic* to *White Wolf*. She has been interviewed for various print and television specials on vampires. Amelia edits *Blue Blood*, a magazine of counterculture erotica which includes lots of vampiric sensuality. And to think Amelia's parents suspected she was wasting their money when she wrote her Honors thesis on cross-cultural vampire legends as a paradigm for human sexuality.

Raven Kaldera

is a pansexual androgyne leather top and priestess of the Dark Goddess who teaches ritual S/M, safe topping technique, and third gender mysteries. Raven is happily married and the parent of one daughter.

Warren Lapine

traded in the wild life of a rock musician for the even wilder life of a science fiction writer. He has made more than thirty sales to magazines such as *Fantastic Collectibles, Visions, Pirate Writings, Gaslight* and the audiozine *Tales from the Grave.*

Pat Salah

is a Montreal writer whose work has appeared in *Hence, The Moosehead Anthology* and *The Lesbian and Gay Studies Newsletter.* He is currently studying Queer theory at Columbia University and working on a manuscript of linked stories and poems entitled Snow White's Children.

Dave Smeds

is the author of the novels *The Sorcery Within* and *The Schemes of Dragons* as well as many short stories that have appeared in *Asimov's*, *The Magazine of Fantasy and Science Fiction*, and *Full Spectrum*. as well as the Circlet Press anthology *TechnoSex: Cyber Age Erotica*. He has sold over three dozen works of erotic fiction to *Club International*, *Hot Talk*, *Penthouse Forum*, *Club Mayfair*, and *Lui*.

Cecilia Tan, editor

founded Circlet Press for the express purpose of publishing erotic science fiction and fantasy. Her own work of erotic fiction and erotic sf has appeared in such diverse outlets as *Penthouse*, *the Herotica 3 anthology*, and *Sandmutopia Guardian* magazine. Forthcoming projects include editing an anthology of sadomasochistic sf from Richard Kasak Books, and stories in <u>Paramour</u> magazine and the anthologies *Sensual Delights: An Asian American Erotic Feast*, *Herotica 4*, *By Her Subdued*, and *Looking For Mr. Preston*.

If you like what you found in this book, you may also enjoy the rest of the Circlet Press, Erotic Science Fiction and Fantasy line... including

Blood Kiss: Vampire Erotica
 Explore the sensual side of the night!
Wired Hard: Erotica For a Gay Universe
 Some of the best combinations of sf and gay erotica ever.
Queer Destinies: Erotic SF/F by Gary Bowen, $5.95
 Gay male erotic visions in fantastic universes.
Worlds of Women: Sapphic SF Erotica, $5.95
 Lesbian and bisexual women's futuristic fantasies.
Telepaths Don't Need Safewords, C. Tan $2.95
 SM meets sf in this original chapbook.
Mate: And More Stories of Erotic SF/F, L. Burka $3.95
 A cyberpunk future meets the game of dominance.
Feline Fetishes: Tales of Erotic Science Fiction $5.95
 For anyone who has ever meowed during sex.
Forged Bonds: Erotic Tales of High Fantasy, $4.95
 Elves learn of the freedom that comes with bondage.
SexMagick: Women Conjuring Erotic Fantasy, $5.95
 Myth and magic mix with erotic power.
TechnoSex: Cyber Age Erotica, $7.95
 Virtual reality, perfect androids, automobiles, and sex.

Please add $1.50 postage & handling per book when ordering by mail. Also include a statement that you are over 21 years of age. Massachusetts residents must add 5% MA sales tax. Send check or money order to:

Circlet Press, Inc.
P.O. Box 15143
Boston, MA 02215

Bookstores may order direct from Circlet Press, Inc. or through our distributors: Inland Book Company, East Haven, CT and Last Gasp of San Francisco. Retail discounts available.

Is your appetite insatiable? Try some of these....
All prices include shipping and handling.

Daughters of Darkness: Lesbian Vampire Stories $12.95
 An intense collection of vampiric tales, new and old.
Manmagic: The Fantasy Male Nudes of Tristan Alexander $23.50
 Striking black and white art including vampires, faeries, etc....
Vampire Dreams $5.00
 A chapbook of vampiric fiction from Obelesk Books.
Meltdown Erotic Dark Fantasy $14.95
Bizarre Dreams Gay Male Erotic SF $6.50
The Initiation of PB 500, Kyle Stone $6.50
 A gay erotic sf novel combining SM and a dark masculinity.
Queer Destinies: Erotic SF/F by Gary Bowen $7.95
 The first collection of short stories by Gary Bowen.
Macho Sluts, Pat Califia $12
 Hot collection of SM short stories, including sf and vampire stories.
Melting Point, Pat Califia $12
 The new, hot collection from Pat Califia. Main focus is lesbians, but
 also includes gay men, gender bending couples, and more.
The Claiming of Sleeping Beauty $13
Beauty's Punishment $13
Beauty's Release $13
 Anne Rice's trilogy of intense SM/BD fantasies.
Mad Man: A Novel $28 hardcover
 The newest from Samuel R. Delany! Heavy sex & twisted minds...

With your order, be sure to include a statement that you are over 21
years of age. Massachusetts residents must add 5% MA sales tax. Send
check or money order to:

Circlet Press, Inc.
P.O. Box 15143
Boston, MA 02215

Send a SASE for our complete list
of hundreds of titles of erotica, sexuality, graphic novels,
photography & art, how-to books on SM/leather, body art,
classic erotic literature and more!